The Travelling Painter

A companion, tutor and guide

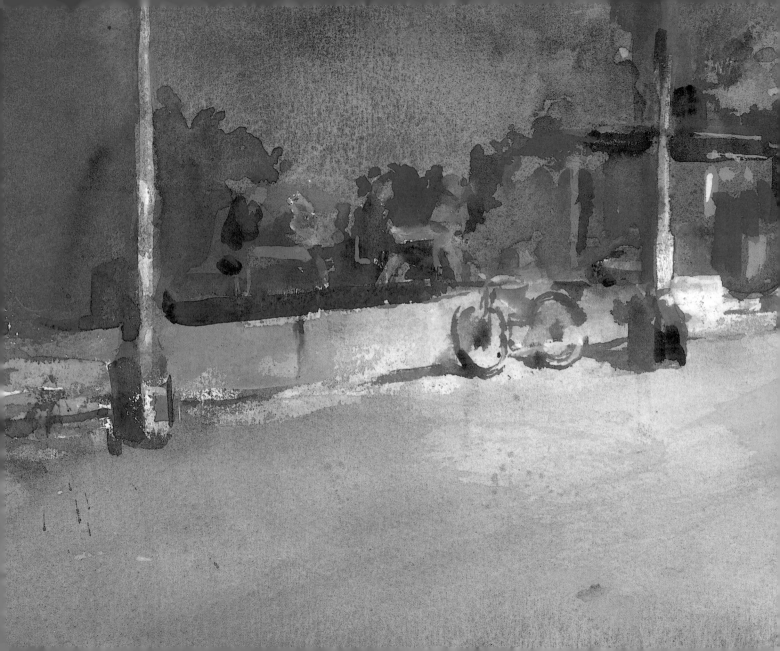

The
Travelling
Painter

A companion, tutor and guide

Paul Millichip

B. T. Batsford Ltd,
London

To Shirley

First published 1990
© Paul Millichip

All rights reserved. No part of this publication may be reproduced in any form or by any means
without permission from the Publishers

ISBN 0 7134 6451 8

Printed in Hong King
for the publishers,
B T Batsford Ltd,
4 Fitzhardinge Street,
London, W1H 0AH

Contents

Acknowledgements 6
Introduction 7
 1 Choosing a Location 11
 2 Packing 25
 3 Travelling and Arriving 39
 4 Exploring 49
 5 Excursions 79
 6 Observing Close Up 109
 7 People 125
 8 Cities, Towns and Villages 145
 9 The Sea 165
10 Returning 191
11 Painting Places 197
Index 223

ACKNOWLEDGEMENTS

For practical help with travel: Timothy Tims of Timsway and Annie of Creative Leisure Management, Laskarina Ltd. For warm hospitality and travel in America: Ed and Millie Voorhees. For information on the Netherlands: Fiona van Rossem. For patience, persistence and professionalism: my editor. For unflagging support and encouragement and for typing and retyping my manuscript: my wife.

Introduction

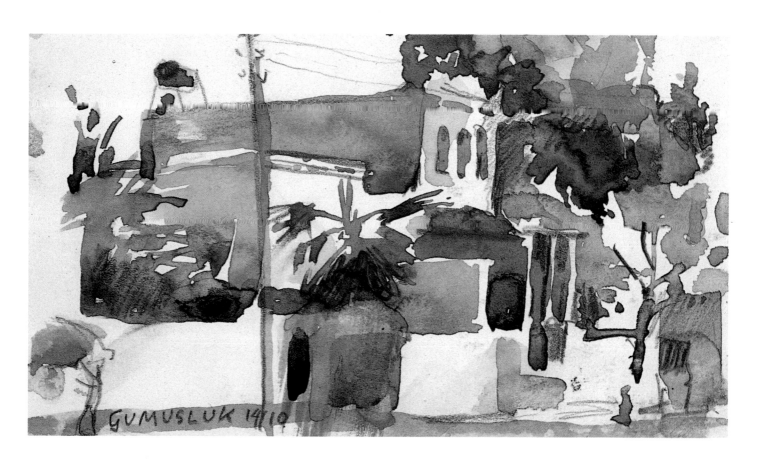

From my sketchbook

8

Today is the day of instant travel – of arriving rather than travelling hopefully. Today is also the day when more and more travellers enjoy doing some drawing and painting during visits to other places. The excitement of contrasting sights and a different light are important aspects of travellers' experiences. To record those experiences on paper or canvas adds a new dimension to any journey.

In past times travellers knew this, and organized expeditions always had an artist on hand to record whatever was new or interesting en route or at the destination. Photography has largely replaced the painter in this role, but it can hardly replace the pleasure of confronting a subject that has caught the painter's eye and offered the challenge of making from it a picture which relives that first experience. The act of painting opens our eyes.

As a painter and teacher I have been concerned for years with introducing people to the enjoyment of painting in different parts of the world and helping them to see with the eye of the painter. Every course I tutor abroad is preceded by questions from its potential members about the best materials and equipment to bring. I have dealt with these questions in this book. More vitally, I have tried to share my painter's vision and show how this way of seeing the world can sharpen the perceptions and enrich the life of anyone prepared to take on the challenge of the travelling painter. I hope this book will be a worthwhile companion and practical tutor.

Good painting!

From my sketchbook

1
Choosing a location

Be winged arrows aiming at fulfilment and goal.

Paul Klee

From my sketchbook

12

As a painter you are a special kind of traveller. Whether you draw and paint for most of your waking hours or only on rare occasions, your needs as a traveller will be different to those of others. You will certainly have to consider most carefully whether your concerns as a painter are compatible with those of your friends or members of your family with whom you are thinking of travelling. 'Do you have to stop there?' your companions may well cry as you pause, sketch book in hand, on the corner of some busy city square to register the view of a charming group of buildings. 'Oh, not again!' may be the reaction when you ask for yet another car halt while you note the colours of that delicious segment of landscape. You are probably blessed with the most charming and tolerant of partners and friends but, nonetheless, your wish to pause and draw, or even just to stand and stare, may well try the patience of the most understanding of travelling companions.

One solution is to travel and work with like-minded people by joining a painting course or workshop; in many years of tutoring I have generally resisted pleas for non-painting partners to join my groups abroad; those who have committed themselves to such a demanding activity as painting hardly need the distractions that non-painters might provide. Advertised in the art press of several countries, especially in America and Britain, are many such workshops covering a wide range of venues. Although the choice is large, there are several considerations that as an intending course member you should take into account before committing your time and money to one particular organizer. To start with, consider the nature of the countryside in the area of the proposed trip. Some painting workshops are based in mountains, but there are some people, like me, who enjoy seeing mountains but have no wish to paint them. Weather and climate are considerations. In North America, on the eastern seaboard, the climate is conditioned by the ocean, just as it in Britain and western Europe. This can lead to exciting painting possibilities, with such elements as wind and sea mists coming into play, but may prove unsettling to those who prefer a constant light and temperature whilst they work. Painters may well wish to avoid southern Europe and north Africa during the hot summer months. Fine conditions perhaps for swimming and sun bathing, less satisfactory for painting, when shady vantage points are at a premium, strong sunshine has bleached the local colours, and intense heat after mid-day dictates against activity of any kind – including painting.

Some knowledge of the work and attitudes of the tutor on your chosen workshop will certainly help. A brilliant and famous artist may well be uninterested in the day-to-day business of tuition, especially of beginners. Another potential teacher may have little sympathy with your own chosen painting medium, a point worth checking. Personal recommendation will be useful here – alternatively, the editor of your favourite art magazine may be able to guide you. It can certainly be helpful to visit an exhibition that contains work by a potential tutor,

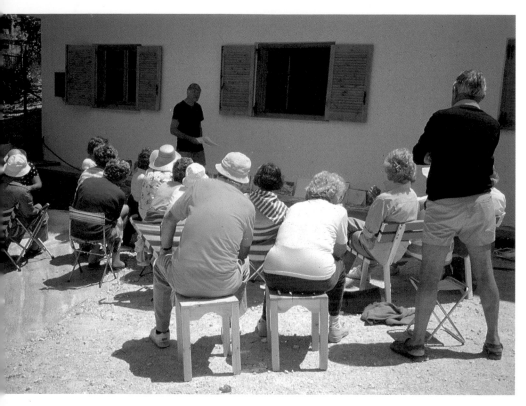

organizers and tutors know the planned destination, and how well organized their itinerary seems.

If you do opt for a painting workshop you will probably find that the organizers or your tutor have structured the working days in some way. When I am teaching I like to start most days positively with a meeting and a talk about some aspect of the work in hand, possibly with a chat about relevant technical problems. Workshop members then disperse to their chosen sites in the area and I do some brisk walking to try to see all of them and discuss their work with them individually during the morning, unless they tell me that they prefer to work on their own. Afternoons are kept free of teaching so that students can develop their work and we all meet up again in the early evening for an in-depth critique and discussion of the day's painting. Other tutors may structure their days in different ways, but this is probably a fair sample of how things may be run. A workshop's atmosphere should develop with its members and they should have the

Briefing a painting group in Greece

to establish whether treatment and approach are congenial to you. Best of all, make a telephone call to the workshop organizers, speaking if possible to the tutor. Check the price against that of other courses and workshops, paying particular attention to what is included – e.g., travel, bed and breakfast, half board, full board etc. Insurance may be part of the cost or possibly an extra. In certain instances you may have to arrange insurance for yourself. Check also how well the

satisfaction of knowing they have learned something useful at the end of their one or two weeks, especially in relation to the different environment and light in which they have been working in a different country or district.

The social side of being part of a group abroad is obviously a delightful aspect of the whole event for travelling painters; shared interests against the background of a different culture with perhaps a foreign language and unfamiliar food frequently bring folk together and form the basis of lasting friendships. Anyone who has attended a painting workshop knows that painters are the most sociable and friendly of people, and swimming, walking and dancing are often very much part of the leisure activities.

Those who prefer to travel and paint on their own will probably be the more seasoned travellers and more experienced painters. They will enjoy journeying in their own way and at their own pace. These days, travel by plane, boat, car or train or a combination of these can allow for great flexibility and there

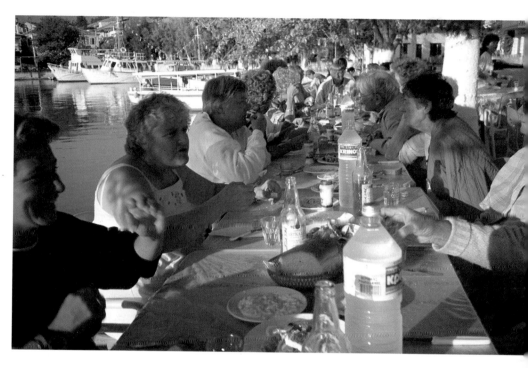

A group sharing a meal at the harbour side in Greece

are agents who specialize in versatile itineraries, which they will be happy to work out in consultation with clients who have special interests, such as painters. By using charter flights and booking hotels at favourable rates, such agents can offer a very competitively priced deal to individual clients, along with the flexibility which the painter needs. Today's fly-drive arrangements are also admirably suited to the independent traveller.

One does have to be careful, however, about choosing 'package' holidays as a painter. A distinction needs to be firmly made between

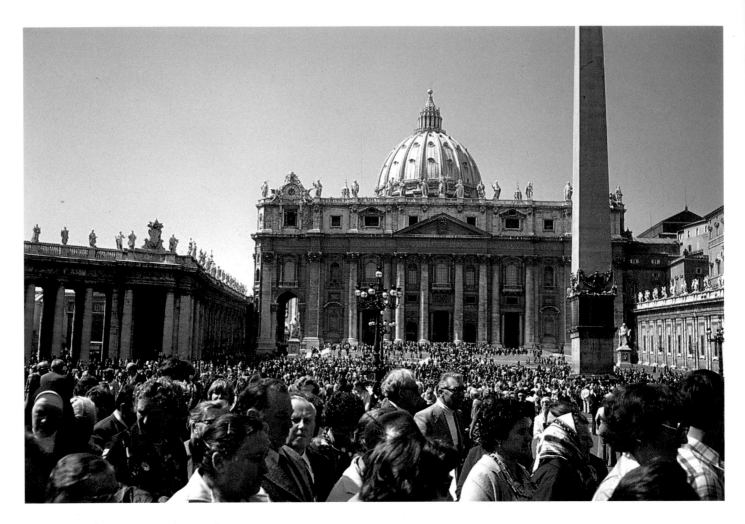

Tourist crowds in St Peter's Square, Rome.

painting and sight-seeing. Artists often return despondently from the great cities of the world, having been so overwhelmed by the tourist sights and the crowds that they have drawn or painted very little.

Another problem is that paintings of famous landmarks can verge perilously on the edge of reportage. As painters we should surely be trying to look a little under the surface of the places we visit in order to present our individual attitude to them – not an easy process when the prevailing image is the received one of some world-famous sight. Of course you can recall Delaunay's painting of the Eiffel Tower and Monet's various versions of Rouen Cathedral, but these are examples of painters using famous images as a peg on which to hang their personal ideas and approach. Indeed you might find more individual and creative expression arises from choosing an anonymous backstreet or casual frontage for your subject.

Another situation which wise painters would do well to avoid is the tour or multi-centre arrangement, particularly if it means travelling by coach and stopping only for a brief time at each centre. This can lead to a sense of unfulfilment arising from brief encounters with new images and resulting in paintings which merely skim the visual world – a situation to be aware of also if you hire a car. It is often better to chose a good base, simple with adequate accommodation, which, although not necessarily within reach of world-renowned sights, has pictorial possibilities reachable both by foot and car. Ideally, choose a location near both town and country subjects too – not an especially difficult condition to fulfil but one which will repay a little research before you plan your voyage.

Having decided upon which country or area you wish to visit and paint, you may then call on a travel agent. These days most resorts or towns of any size have coverage from several agents. Let us say your interest is in a Greek fishing village with whitewashed houses, clear light, brightly-coloured fishing boats. Several travel firms will have presented enticing brochures of this place, especially if there is a good beach available. Collect a handful of these brochures and study them carefully. Scrutinize tour operators' descriptions and try to read carefully 'between the lines'. Remember that these brochures are not written for painters but for those who yearn for the most generally popular prerequisites of a southern holiday – sand, sun, sea. You will probably be travelling either before or after the main travel season, the so-called shoulder season! Currently many countries have added to the natural attributes of their seaside villages and towns by opening up facilities such as discos and pizza bars – facilities which you may want to forego. Watch out for mention of these in the brochure and try to ensure that your lodgings are not within ear or nose shot!

Watch out, too, for evidence of those featureless concrete blocks that are rapidly replacing local building, especially in southern Europe. Rigorous questioning of your travel agent and careful study of recent guide books should help you establish whether the area you are interested in visiting still retains some of its native character.

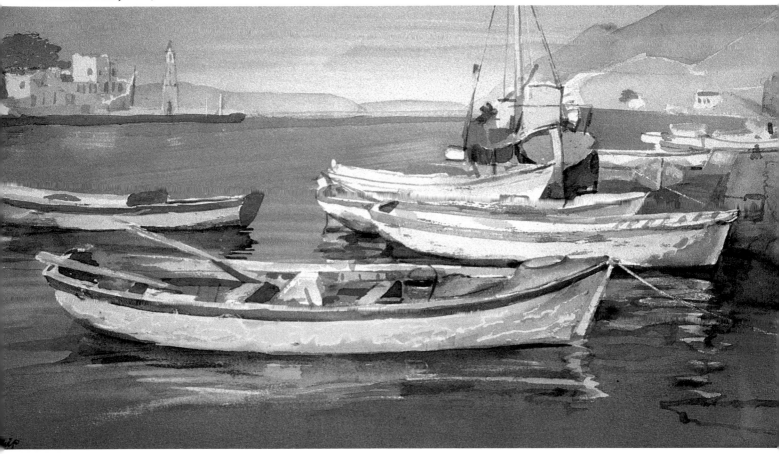

1 **Boats in harbour, Greek Fishing Village**, *watercolour 14 × 30in (36 × 76cm)*

2 (left) **Portuguese Village**, *watercolour,*
16 × 22in (41 × 56cm)

3 (right) **Moroccan gateway**, *watercolour,*
30 × 22in (76 × 56cm)

Of course, if you opt for a city painting trip, the problem of getting to your centre destination will be minimal. Weekend breaks are usually holidays in cities that can be taken throughout the year and they are a relatively cheap way of seeing whether a location holds interest for you as a painter and whether you wish to return there to work more seriously and for longer. Since the built environment, but not necessarily the tourist sights, will be your reason for a city visit, you will probably look for accommodation near the middle of the town. My favourite hotel in Amsterdam has windows giving a wonderful viewpoint onto the canal, a definite plus for a painter. Venice, as one would expect, has innumerable hotel rooms offering sight of the water – again it is worth mentioning to your travel agent that you are a painter, and asking specially for a room with a view. Bear in mind that such a room may well bring more traffic noise,

however, whether the traffic is road or water-borne. Bear in mind also that you are less likely to feel inhibited about painting in your room if the accommodation is relatively simple.

Landscape painters looking for a suitable base for excursions into the countryside might consider the vagaries of the weather, especially if they intend to work in northerly countries. One hears sad stories of those setting out with high hopes to paint rural views only to be washed out by a week of torrential rain.

Finally, choose an off-season time to travel so that you can avoid the tourists, see the country in its most natural state, and even have a room to do some painting!

Amsterdam

From my sketchbook

24

2
Packing

Porter, I also have a portmanteau in the corridor.

Old phrase book

From my sketchbook

The telephone rings. 'How many brushes should I pack and what size?' 'Should I bring stretched canvases or stretch them when I arrive?' 'Should I bring oil paints or water colours or both?' 'What about pastels and acrylics?' 'Can you recommend suitable clothing?', and, 'is sun guaranteed?'. 'Shall I pack a stool and easel?' 'What about immunization?' 'What time is the train, flight, coach?'.

Happy the lot of the painting course organizer who knows the answers to these and many other questions.

Imagine that you have consulted all the oracles – the travel agents, your friends, your atlas, the painting course advertisement in an art magazine. You have taken the plunge and booked – either as a member of a group of painters or a solo traveller. You have decided on a fortnight abroad, a great adventure. What should you pack into that suitcase that lies so invitingly open on the bedroom floor? First, ensure that suitcase is not too large or too heavy in itself. In many parts of the world the age of porters is long passed, and even baggage trolleys are not always available. Real leather luggage looks impressive but is very heavy. Plastic, canvas or nylon may not look so elegant but is lighter and can usually be folded and stowed away in the possibly limited space in your accommodation. Also avoid suitcases with little wheels built in, or on trolleys. Fine in town situations and on smooth pavement, but no so easy to manipulate on stony terrain or up steep village steps. A good alternative to a suitcase is a modern lightweight rucksack that will hold painting gear and adequate clothing with ease and leave the hands free for coping with different aspects of the journey. I am proud to number several octogenarian backpackers amongst my students.

Remember that, away from beautiful townscapes such as Venice, a painter may well be in search of the appeal of the simple and rural and the facilities to hand, including road surfacing and plumbing, may be simple and rural to match.

So here is your lightweight case, hopefully soft-topped for easier packing, and not larger than 24 × 18 in. (61 × 46 cm). You are a serious painter – therefore the first things you pack are your painting materials. Watercolour painters will need a light but strong board made of marine ply or reinforced plastic composition, not less than 20 × 16 in. (51 × 41cm) on which to stretch paper. As Ruskin said, 'no painter who knows his business ever uses a block book' – reason, the paper buckles with the first wash. About two dozen sheets of water colour paper, full sheets cut into four will do well, plus a few sheets of good cartridge paper of the same dimension can also be packed easily into the bottom of your case. My preferences for watercolour paper are for Arches, Fabriano and similar makes, that is those with a less absorbent surface. Such papers contain more glue size, which means they are less white in finish, but this small drawback is nothing when set against greater strength and manuoeuvrability. More of this later.

My equipment laid out together with my case before packing to go abroad
On the left, inflatable cushion with paint rag upon which are placed my oil painting brushes and knives. Drawing-board clips, pencils, watercolour brushes with craft knife on the right. Box of spare blades, sandpaper. Above these is my palette plate, resting on sheets of watercolour paper and painting boards. To the right is my oil palette with three plastic bags on it. One contains tubes of watercolour, six colours plus white, my oil colours, six colours plus white. Another my linseed oil, masking fluid and oil dippers. The palette rests on my lightweight marine ply drawing-board with cut-down water bottle for carrying water, sponge, brown-paper tape, putty rubber. In front of these is a roll of plastic 'cling' film for packing wet paintings etc. To the right is my sketchbook and above this, cork-screw, scissors, plug adapter, flash-light, razor. To the right of these, my spongebag including suntan oil. Above the paper on the left is a small electric anti-mosquito device with pastilles. Lightweight cotton clothing along the top and right of the group includes a sweater for cold evenings, lightweight rain-coat in case of showers and swimwear. Optional easel is at the top.

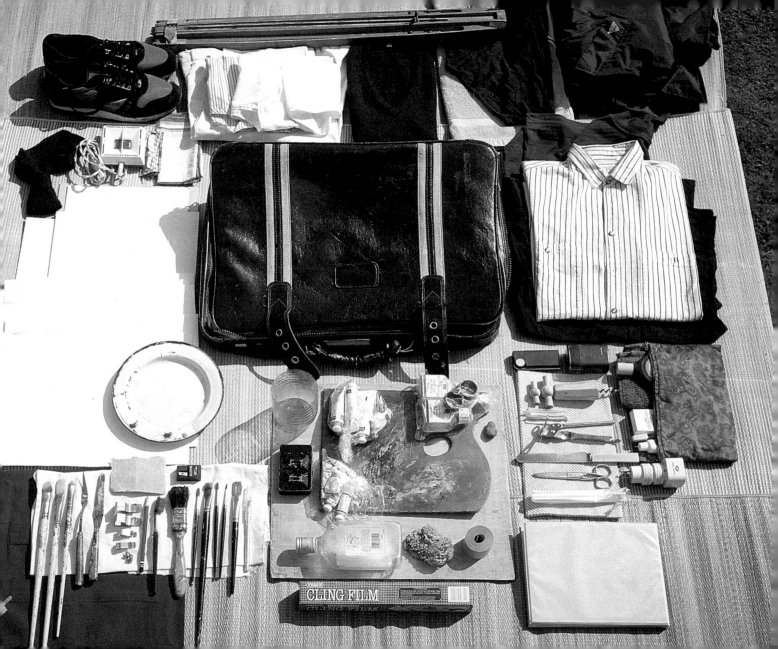

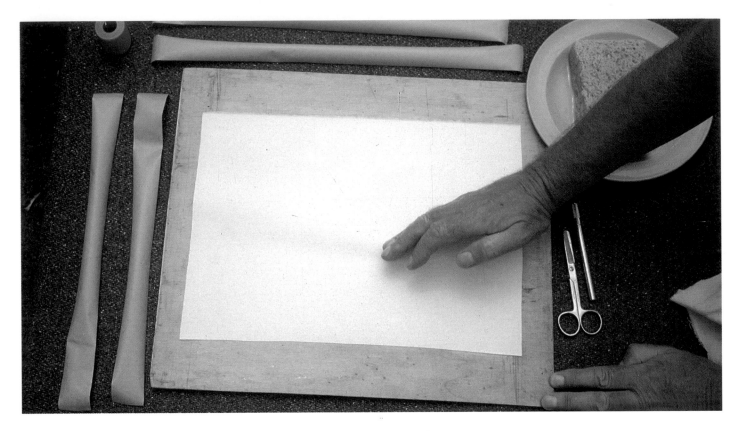

Since I paint very fluid watercolours, I always stretch my paper to avoid it buckling, running cold water across both sides of it in the sink or shower, placing it on my board and removing excess surface water with the edge of my hand.

After a five minute pause to let the paper settle, I stick it firmly round the edges of the board with 2 in. (5 cm) brown paper parcel tape that has been duly damped.

Smoothing dampened paper onto the board before sticking edges with gum strip

If you plan to paint in oils you could pack some prepared boards. Either buy a proprietary board consisting of cardboard with a canvas texture, or make your own boards by cutting muslin 2 in. (5 cm) larger all the way round than a piece of hardboard, turned over on the back and pasted down with wallpaper paste, then primed on the front with white emulsion paint. This home-made surface has the advantage that it can be prepared to any size you wish to work. Alternatively, many painters pack canvas and stretchers and a lightweight tacker gun, or a box of drawing pins (thumb tacks). All these items should be packed flat into the bottom of your case first.

Tacking canvas to an assembled stretcher using a lightweight tacker gun

Now for your colours – first, can I beg you to leave at home your beautiful mahogany paint box with its lines of tubes of paints and its lovely metal containers for bundles of brushes. Once you have lugged it to an airport baggage check, through customs and up several hundred metres of steep steps to your accommodation, it may not be so lovely. Let me propose an alternative based on experience. A simple, sealed plastic bag containing, in the case of oil painters, seven 37 ml tubes of paints. In the case of watercolour seven 14 ml tubes, all with caps firmly screwed on! Remember the leakage potential of an aeroplane's pressurized cabin. Colours as follows: Winsor Yellow, Yellow Ochre, Cadmium Red, Alizarin Crimson, French Ultramarine Blue, Winsor Blue, White (Flake, Permanent or Titanium). The colours are suitable for watercolours or oils and will cope very well with the problems of rendering light and shade in countries abroad.

Oil painters should bring a wooden palette, preferably no larger than 13 × 10 in. (26 × 33 cm) and a double dipper to clip on it for oil and turpentine. Please avoid those disposable tear-off palettes – nothing but a nuisance with their slight absorbency, which takes all the pleasure out of colour mixing, plus their tendency to blow about in high winds.

For watercolour painting, my mixing palette is very simple – a white enamelled metal plate obtainable from a camping equipment or hardware store, about 9 in. (20cm) across with a good deep bowl and a wide rim. All the patented palettes currently available, usually with fussy little compartments, cannot beat this simple item.

Brushes – again be austere with yourself and leave weighty brush containers behind; instead wrap your brushes carefully in a length of paint rag. Oil painters will not need more than three brushes, and I recommend a Winsor No. 9 series 80, No. 7 series CL and a No. 4 CL, all in filbert shapes – very versatile brushes. A small knife for palette

scraping plus a good flexible painting knife will be useful. Watercolour painters who have been painting for some time will have favourite brushes. Mine are a square ended lettering brush 5/8 in. (17 mm) wide in sable and ox mixture, a 1 in. (25 mm) house painters' brush, the more worn the better, a soft mop brush and a no. 5 sable with a good point on it. I find this group can deal with most painting contingencies. Take a small sponge and a good soft paint rag too. I also take a small craft knife and a little sandpaper for scraping work.

If you are painting with oils, you also need some refined linseed oil; turpentine is not allowed in your baggage if you fly since it is inflammable, so avoid trouble by leaving it at home and learn the word for 'turpentine' in the language used at your destination when you ask for it in the local hardware store. Your bottle of linseed oil should again be contained in a sealed plastic bag. In Greece, oddly enough, turpentine is sold by weight and may well be the proper stuff, redolent of pine

woods – a great pleasure to use. An alternative is to take a tube of a patented painting medium. Watercolour painters will need a water container and can benefit from the many lightweight plastic containers available; I use a plastic half litre whisky bottle which I enjoy emptying for the purpose! Alternatively, there will be plenty of cheap drinks, including water, available in plastic containers at your destination, especially if you go to a southern country. I usually cut down a drinking water bottle soon after arriving and find this a very convenient container. Above all, don't pack heavy breakable glass bottles or jars.

From my sketchbook

Painters in watercolours will not need easels. I used to go painting outdoors with a friend, still one of the finest artists I know, who never even took a drawing board on site. He placed a piece of paper on the ground, weighted it at the corners with four stones, and crouched above his work. Gradually he produced an exciting painting to the accompaniment of much scribbling, splashing and groaning. Perhaps a little too casual on the technical side for some, but a refreshing contrast to those who worry away so much about their art materials that the painting itself almost gets forgotten! Anyway, the ground, a convenient wall top, or your knees can all provide a surface level enough for you to place your drawing board on.

Watercolour used on a vertical surface can never be used wet enough unless you enjoy playing catch games with washes running off the paper. And what of those acrylics and pastels I mentioned earlier? I may as well confess my personal prejudice against acrylic paints, which were, incidentally, developed from emulsion paint.

Acrylics dry quickly, so many think they should be ideal for the travelling painter – no problems with transporting sticky pictures. The trouble is they can dry too quickly, especially out of doors in a warm climate – so you can find your palette with piles of dried-out paint on even before you have started painting your picture, in spite of the sprayers and retardents sold to slow up the drying. I feel that painting is a difficult enough business without having to contend with an unsympathetic medium. Acrylic is ideally suited perhaps to studio painters of abstract pictures, but not always appropriate for the subtle movement and mixing of paint when we are working from nature.

Pastel is without doubt the most difficult medium to master and to transport, being fragile, easily-smudged, requiring a carefully chosen support, needing very precise mixing on the painting's surface, and very disposed to crumble messily in a packed suitcase. I would add that I have seen excellent work done in both these media and I would suggest that you take either or both if you must, but at least be aware of the problems they present for the travelling painter.

There is an enormous range of folding stools and chairs on the market, some of them lightweight and reasonably comfortable. Older painters may prefer to carry one of these. Most folding seats will only operate properly on level ground. They can and regularly do let people down on the kind of rough and sloping terrain which is common in rocky and mountainous areas. Consider a practical alternative, a stout inflatable cushion which will fold up neatly into your case, and can be puffed into use and placed on a convenient rock or doorstep to allow reasonable comfort whilst painting, doubling as a pillow if necessary.

Now for the contentious question of portable easels. Should you take one when painting abroad? I have seen many of these in action over many years, often decked out with the comforting little gadgets beloved of some painters – hooks and ledges for palette and water jars, string for attaching toilet rolls, brackets for drinks and cups of tea.

Delightful, and attesting to the needs of many an aspiring painter to feel a sense of security in a possibly alien environment. Let me add, though, that these easels all appear to cater for painters of 5ft 6in (1.65m) and under. I happen to be well over 6ft, and find that an hour or so standing at one of these leaves me with a cricked neck, which will then last for several days. All of these easels, whether folding, wood, or telescopic metal, are also appallingly difficult to erect to a satisfactory working height and, once erected, difficult to keep steady if a little vigorous painting or a strong breeze is in progress. If you wish to take your easel abroad with you it may well be hard to find one that fits into your case. You may prefer to transport it unwrapped and be told by baggage reception that you will have to carry it as it might damage other baggage. As you carry it onto an aeroplane you may be asked to relinquish it as it could be used as a weapon. My own easel once crossed between Britain and Greece twelve times – it had been pushed to the back of the plane's baggage hold and caught up with me in

Greece the day before I was due to return to Britain. There are many ways of improvizing on an easel, including using a chair back to prop your painting against.

The next piece of equipment is the most important of all – your sketch book. This need not be large, A4 or A5 are convenient sizes, but it should have a rigid back and preferably a waterproof cover. I like those books containing smoothish paper over which the pencil can move quickly. I find 3B pencils will give me a reasonable quality of line and also register a good range of tonal values, and I also carry several with my sketch book, together with a small pochade box. Since many of my paintings of places abroad are done from sketch book notes in my own studio in Britain, the reason for my stressing the importance of the sketch book becomes clear. I am rarely parted from it on a trip abroad and it is carried in my only other article of baggage, a canvas shoulder bag. This bag, originally made for a fisherman, is not elegant but is stoutly made and waterproof lined. It goes with me as cabin luggage

and, besides sketch books, contains pencils, sharpener, a camera, and sometimes a pochade box.

Pochade boxes – those handy little watercolour boxes, often with an integral water container and a small paint brush – are very useful indeed for rapid on-the-spot colour notation. I find I can draw and add colour notes whilst attracting minimal attention with an A5 sketch book and pochade box clutched to my chest. My little box has only the six colours (plus white) I have mentioned and I find this adequate for most contingencies. Cameras can of course be as elaborate or as simple as you wish. For simply making a record of light and colour, an automatic, lightweight camera is best.

The clothing that you pack and wear will certainly be conditioned by the time of year and the climate of your chosen painting venue. Countries which are generally warm, southern Europe, north Africa for example, can have surprisingly cold evenings, especially in early spring and late autumn, so do pack a wool sweater or cardigan. Sunny days will be

encountered most comfortably in cotton under- and over-wear – avoid man-made fibres where you can. The fair-skinned from northern countries may consider an outer garment with long sleeves for day wear. Painting is such a mind-absorbing activity that it is possible to become badly sun-burned without realizing it. It will be sensible to include a sun hat, but I would suggest not a large straw one, delightful as these might look. Even the slightest breeze calls for two hands to keep such hats in place and you will need at least one hand free for painting! Lightweight cotton headgear is just as practical and easier to pack in your case. I find sandals the ideal wear in warm countries, although many of the more paintable parts of your area could be along very rough, stony and thorny tracks, so well-soled canvas shoes and a pair of socks can be useful. A good pair of trousers or jeans is also very practical for protection against unfriendly terrain. Although daily life in southern countries is usually very relaxed, many visitors to these countries like to include slightly more formal clothes for dining and evening wear. Keep such attire simple and bring as little as possible. Elegance needs to be balanced with practicality, and the potential usage of each clothing item should be carefully considered. Do bear in mind that in a hot country, even out of season, there should be a few hours of drying sun each day to dry clothes and in cooler countries you can hang a little washing on radiators.

Of course, you will respect the customs of the country you are visiting. Churches and monasteries may refuse admittance to those with uncovered heads, arms or legs. Muslim countries will prefer to see women in public places, including painters, in reasonably discreet clothing.

Other useful items to be packed include a pocket torch (flashlight) – electricity can be erratic in some countries; waterproof outer clothing for more northerly and wetter countries, together with a pair of thick socks which would be welcome to those standing or sitting and painting for long periods in a colder area; swimwear and a towel for a seaside venue.

Shoulder bag contents
Passport with above it travellers' cheques and currency, ticket on the left, maps, guide books, phrase book and reading matter on the right. Below, sunglasses, pencil, sharpener, ball-point pen, camera, film and pocket sketch-book.

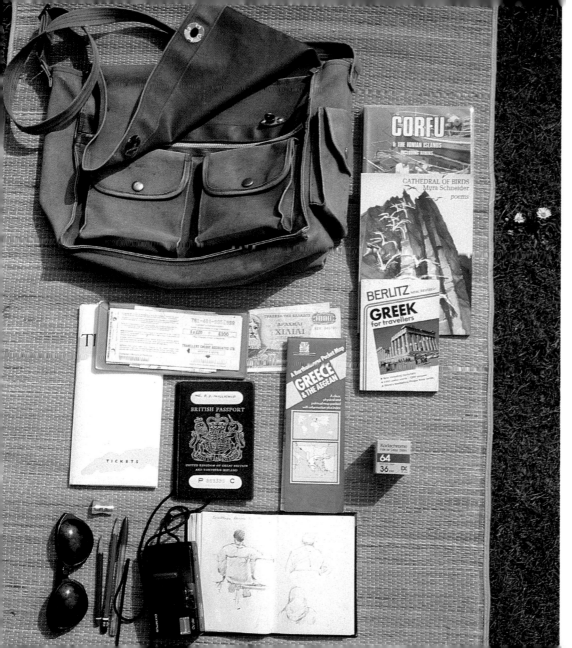

Visitors to warmer countries might consider taking a small electric mosquito repellent with pastilles for use in the room, especially toward the end of the year.

Immunization – check with your doctor who will have a list of the immunization requirements for each country in the world. Some countries may require you to produce a certificate of immunization.

To sum up, in packing remember the two golden rules: if you can't carry it easily don't bring it, and, the simpler you keep your art materials the better.

From my sketchbook

3
Travelling and Arriving

Ah, how big the world is in the lamplight
But how small viewed through the eyes of memory

Baudelaire

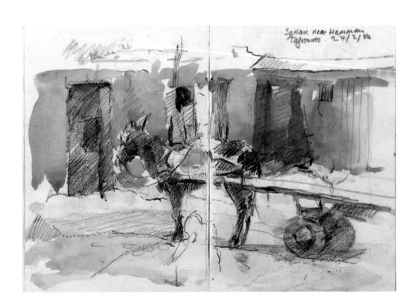

From my sketchbook

40

An airport or seaport at some unforgiving hour in the early morning may be the starting point of your painting trip. When you check in your baggage, if you are flying, your lightweight packing will surely keep the baggage weight well within the limit, but check this weight (probably 44lb (20 kg)) on your airline ticket. Be sure to retain your in-flight or in-voyage cabin bag. This bag will contain your sketch book and pencils and this is where your potential as a travelling painter really begins to tell. Should there be delays before departure you will have an admirable opportunity to make drawings of the scene in general and of your fellow passengers in particular, sitting, watching, reading, strolling up and down – you have captive models there before you. Make the most of it. What better opportunity to 'get your eye in' especially if you haven't drawn or painted for some time. Don't miss your flight or sailing though!

The journey itself may also offer a chance for drawing. On a boat you can wander and make notes of the receding shoreline, the boat's superstructure, your fellow passengers, perhaps even the sea gulls! A plane may offer little other than observation of the different shapes of the tops of other passengers heads but remember, all this observation and notation is preparing your eye, hand and brain to make the most of sights to come.

Arrival at your destination port or airport will invariably entail some tedious waiting for customs checks, passport control and baggage collection but here is an opportunity for your painter's eye to note that all important factor, a different quality of light. If you have travelled to a warmer country than your own you will be aware of the shape and definition of shadows in sun-light. A cooler or more misty scene on arrival offers the chance to compare tonal greys, and after-dark arrival gives you the opportunity to absorb dramatic contrasts of light and shade. Keep your eye alert, a painter is never off duty!

Painting party leaving plane, Greece

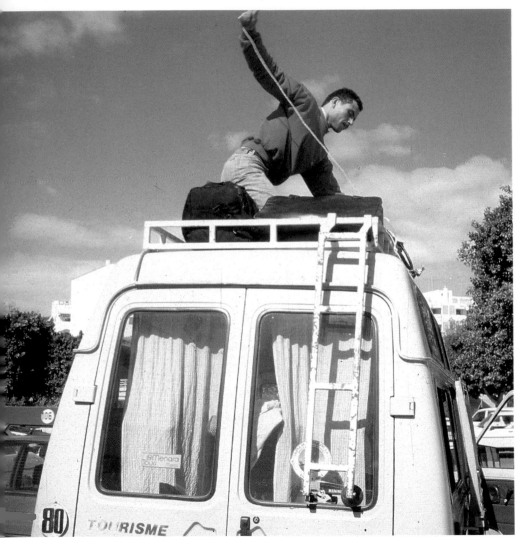

If you take a coach or bus trip from your arrival point to your ultimate destination this will present you with your first sights, sounds and impressions. I remember a working visit on a teaching assignment to Sri Lanka some years ago when I was met by a friend at Colombo airport and driven by his Sinhalese driver at hair-raising speed through narrow streets overflowing with people, dogs, chickens, market stalls, ancient bicycles – an incredibly rich mixture of humanity, colour, shape, noise and movement. The key to the excitement of all this was, of course, its unfamilarity to me, and it is that sense of unfamiliarity which should be preserved and nurtured in travelling painters' minds to give spice to their approach to painting away from a

Group luggage secured on the minibus before departure for southern Morocco

familiar environment. Preserving the shock of the new is a most valuable part of the painter's approach.

Many travellers regard their final arrival at their destination with mixed feelings – a sense of relief at having completed the journey is, I find, frequently tempered with a feeling of anticlimax. You are tired, perhaps hungry. You may be viewing your surroundings in a late afternoon light when things do not always look at their best. You turn on a tap in your bathroom, only a trickle of water comes out. There is a strong whiff of drains in the air – a noisy game of football is in progress on the street outside – many arrivals in unfamiliar surroundings are uneasy. I recall a visit to a village on the west coast of Greece late in the year when that sense of anticlimax was accompanied by grey skies, sea mists and the chill of snow in the air.

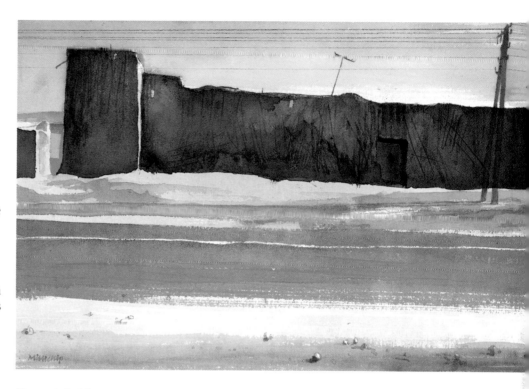

En route in Morocco
Casbah wall, watercolour, 14¹/₂ × 21¹/₂in
(37cm × 54cm)
A mud wall bordering the road; its irregular
silhouette contrasting with the flat lines of
telephone wires and a television aerial.

43

Millichip

44

The remedy? A stiff measure from the duty-free bottle, a meal at the most cheerful looking local restaurant or taverna, a good night's sleep and behold! Next morning the weather has turned round, the sun is glittering on the sea, friendly greetings come from the locals and a good breakfast dispels all of last night's apprehensions. Now we know why we have come here!

View of Sigri, watercolour, 22 × 12in (56 × 32cm)
From the window in Sigri, the study was a first on-site attempt to strike the particular quality of light in this view. The second version was done to convey the quality of infinite space on this coast, using the pictorial proportions of the picture to make this point.

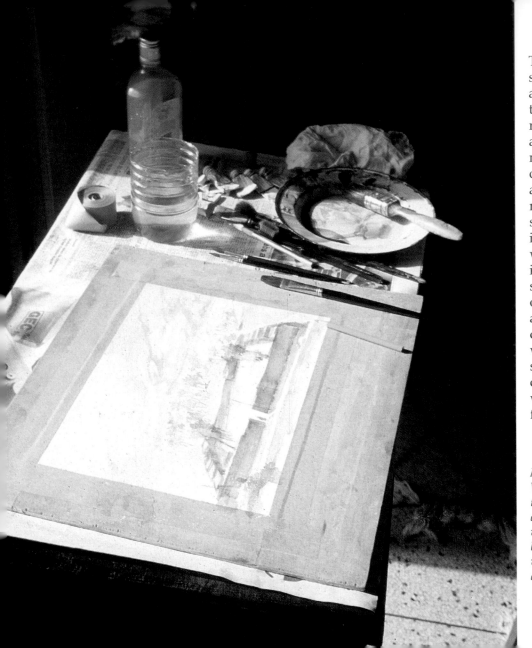

Those who travel and paint are in a special position amongst travellers and tourists in that the room that they occupy, whether in a hotel or a rented villa, will probably be used as a place to work. With this in mind I think it is important to organize the room, however small, as a work-place so that your art materials are to hand and you have somewhere to draw or paint indoors in bad weather or if you want to work on your own. If there is a small table in the room I like to set it up near the window and lay out my painting materials on it, allowing space for my lightweight drawing board. I stretch a piece of watercolour paper on this board straight away and, if I have a canvas to be stretched, I do this as well. Then with paints to hand I feel ready to start.

My work-table
Work-table using one of the available tables in this simple Moroccan hotel room. Besides a drawing-board, the table is laid out with watercolour materials, a plate palette and brushes, plastic whisky bottle for carrying water and a cut-down drinking bottle used for a painting water jar.

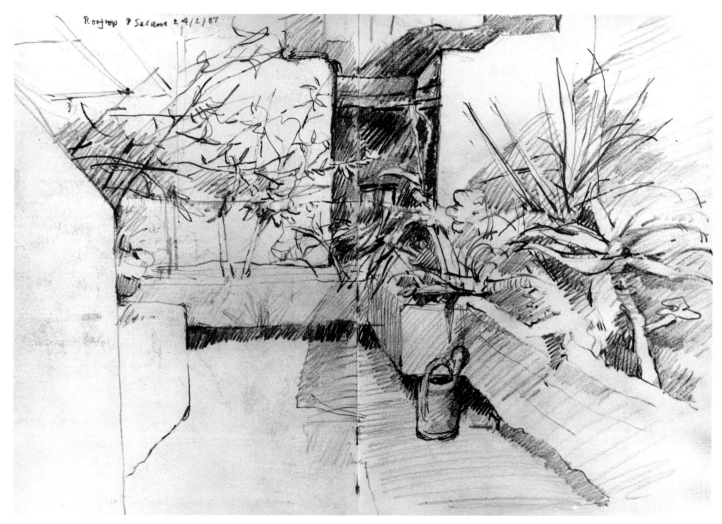

From my sketchbook

If you are in self-catering accommodation, the kitchen often provides a good table-top as well as a floor which can easily be cleaned of splashes, all this allowing for a little creative organization for whoever cooks the meals! Clothes and other accessories should be unpacked and stowed away as soon as you are able to do this. I have seen so many examples of painters trying to do serious work in a small muddled space and fighting the problems which this brings, that I am sure this initial effort is well justified. Painting, like other worthwhile activities, can give rewards in proportion to the amount of care and thoughtful preparation.

From my sketchbook. A good night's sleep is one way to get rid of those initial apprehensions!

4
Exploring

There is no abstract art. One must always begin with something.

Picasso

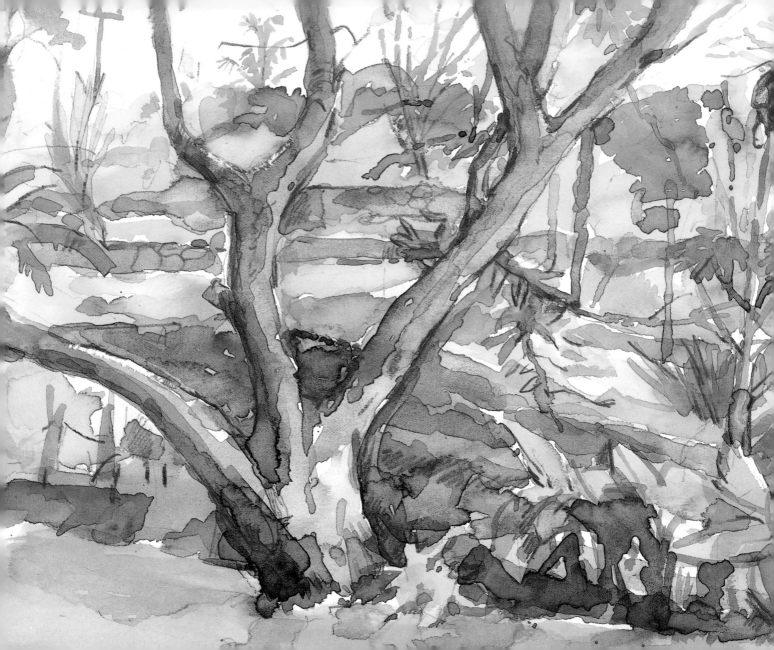

As a travelling painter eager for fresh sights and experiences, you will want to set off on foot on the first day of your stay and explore the new environment, 'getting the feel of the place'. I very strongly recommend leaving your paints in your lodgings for this first reconnaissance – a small sketch book, a soft pencil, your stool or inflatable cushion, perhaps your camera – these will be more than enough equipment for this first tour whether it is of a medieval town, a country village or a rolling landscape 'Tuning the eye' it could be called, this first day – absorbing those unfamiliar shapes and colours, possibly enjoying the effect of a new light, above all detaching yourself mentally from usual preoccupations and activities and opening up to whatever this new place has to offer.

From Frank's Bungalow, Montfort Estate, Sri Lanka, watercolour, 10 × 14in (26 × 36cm)
A quick study to record the lush vegetation and red soil outside a friend's bungalow in this mountain area near Kandy. Coconut palms and mangoes made unfamiliar shapes. Pencil was added afterwards for definition.

At this stage I am not interested in potential picture making at all. I look out for contrasts of light and shade, for texture, for shapes, a tree against the sky, the growth of moss on a wall, the glint of fruit in an orchard, an area of worn wood against stone. All these sights and many more are grist to my painter's mill and as a painter I consider myself the most fortunate of people, since this 'tuning in' helps me to enjoy to the full the visual feast laid out before me.

Rock Study, Tafraout, Morocco,
watercolour, 14 × 10in (36 × 26cm)
From a hotel window in the mountain area of the Ante Atlas. Afternoon sun and back-lighting led to deep rich reflective shadows. Alizarin and Winsor Blue washed over a base of Ochre and Cadmium. I carefully drew in the shape with pencil first, paying special attention to the silhouette against the sky, which also helped me to position the rocks.

Hawthorn Tree, Pembrokeshire,
watercolour, 13¹/₂ × 10in (34 × 26cm)
*Done from a damp ditch on an overcast day in
Wales, a study of a wind-contorted thornbush
silhouetted against the sky. A restricted colour
scheme helped to create the mood of the
painting, and a preliminary tonal drawing in
my sketchbook led to the opposing diagonals of
composition.*

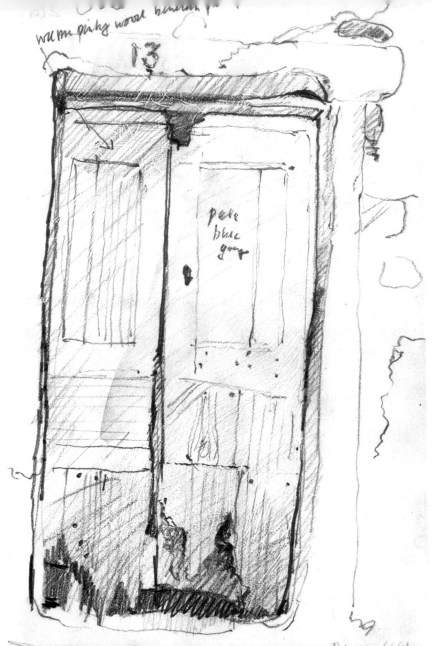

Sooner or later some grouping of shapes or objects will catch my eye and I feel I really must put it down. Out comes the sketch book to record that battered door, the corner of that ruined barn, the prow of that boat – all close-ups or fragments, you will notice, but with tone rendered by shading. This I see as a vital way of beginning to get to grips with the quality of light.

On-site study of a door in a Greek village

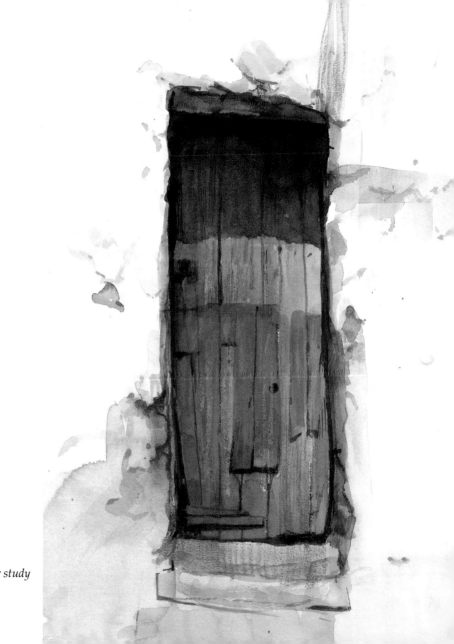

Watercolour and pastel door study

yellow green

Gainsborough

Sketchbook study of a Buckinghamshire barn

56

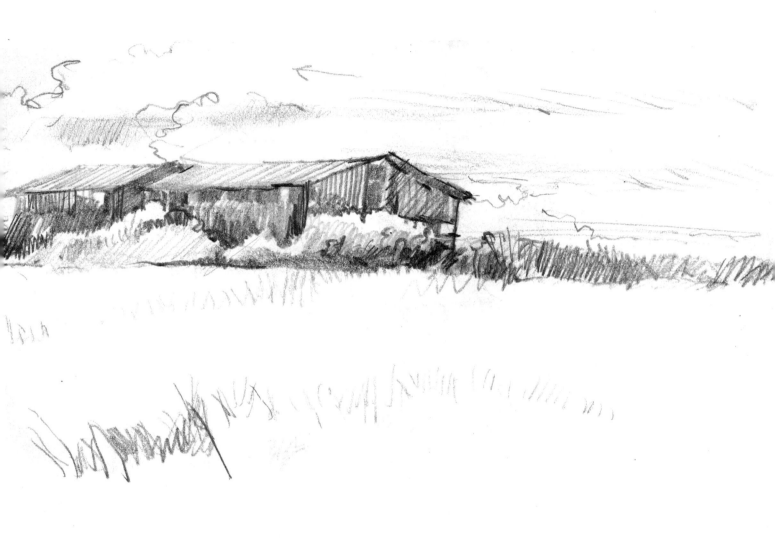

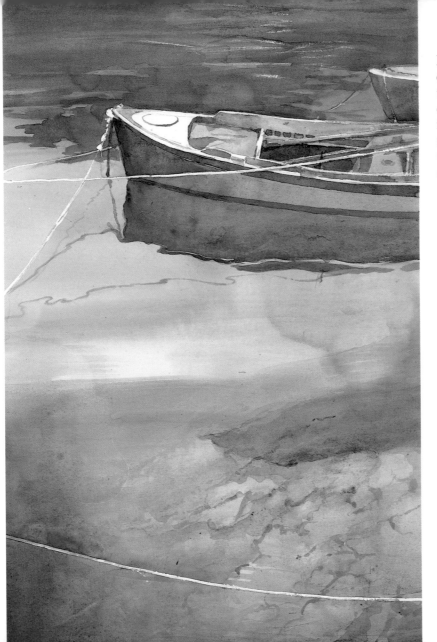

Intense sunlight in a southern country will, of course, offer a wide tonal range with frequent abrupt changes from light to dark. In less intense light, the middle tonal range comes into its own as in a typically British landscape on a dullish day.

Symi Harbour, *watercolour, 28 × 18in (71 × 46cm)*
The clarity of Aegean waters presents exciting painterly challenges. Painted with the sun behind the subject, this involved the boat reflection and its shadow on the stones on the harbour floor below the compositional elements such as ropes and oars playing their parts. French Ultramarine and Winsor Blue were mixed for the water. The greens came from washes of pale Winsor Yellow added later.

Initially, I regard the starting point or subject matter of the drawing as far less important than the approach to the tonal rendering. Some people find it hard to read tonal changes satisfactorily. If this is a problem, try making a tonal strip by ruling a one inch wide scale on the edge of one of your sketch book pages, dividing the strip into about six squares, shading each square in turn darker and darker so that the scale grades from white to black, and then adding numbers. You can then use the strip by referring to it as a sort of interpreter or intermediary of the tones in the view before you. A pair of sunglasses can also help you see 'tonally'. This preliminary period of getting acquainted with the surroundings is one that is vital if you hope to move beyond the stage of the merely topographical or illustrative in relation to a new environment. Many times I have seen over-eager and over-anxious painters dash into new surroundings, dash off a few quick paintings – and finish with hopes dashed! As tutor I find I am then asked to console them, to pick up the pieces and invite them to try again. If you are a *dashing* painter, just try the softly softly approach for once. It need be no less exciting and you may well find yourself seeing more possible pictures in your surroundings. There are other

An example of a tonal strip in six shades

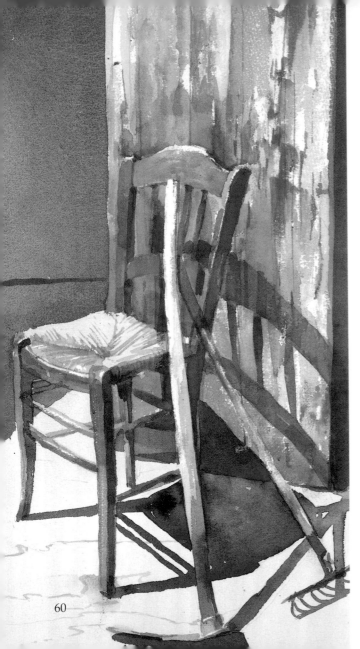

Backyard Chair, Sigri, Greece, *watercolour, 22 × 12in (56 × 31cm)*
I carefully posed these objects in strong afternoon sun in a Greek backyard to demonstrate how everyday things can be given significance by intense clear light and shadow. The crisp precise shadow shapes had to be achieved in a single wash to make them strong yet transparent.

benefits: you will have begun to relate to your new environment as only a painter can; you will have begun to accustom yourself to the whole business of interpreting that environment; and, of course, you may well have lined up some good ideas for a painting in the process. Don't imagine you have no precedessors in this process of playing yourself in. The sketchbooks and notebooks of many a great artist, from Michelangelo to Constable to Van Gogh to Picasso, show how often a powerful idea started from just these preliminary skirmishes.

From my sketchbook

Even if you only have a few days available for painting, a day or so spent on tonal studies will certainly not be wasted. Back in your impromptu studio-cum-bedroom look through your sketch book and check whether some possible beginnings appear: a notation of a shadow cast across a door may become a picture in itself; a grouping of buildings and trees may relate happily to a cloud study on another page of your book. Possibilities and permutations begin to appear. You may well be ready to start painting.

Symi Door, *watercolour, 21 × 14in (53 × 36cm)*
The clear, intense light of the Greek islands again gave sharp shadows with light reflected up into them from the ground. The door shadow was achieved in one wash and involved feeding colour in large brush-fulls into an existing colour puddle.

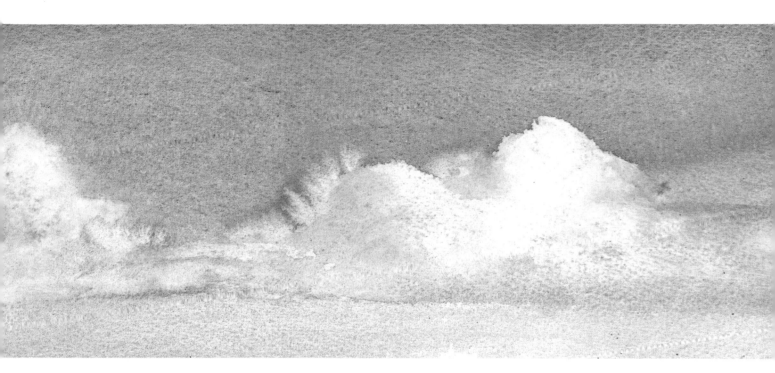

Cloud Study, *watercolour, 5 × 11¹/₂in
(13 × 29cm)
Part of a demonstration for a group in Wales.
A damp cloth pressed hard into a wet wash,
together with a little brushwork with very wet
colour, helps to represent the beautiful cloud
formations over the sea in west Wales.*

This is the stage at which I start to think of an idea for a picture in relation to a specific shape. Will it be portrait proportion, i.e., with the longer dimension vertical, or landscape, with the longer dimension horizontal? Try placing some strips of card or paper (postcards would do) in a small sketchbook, round the edges of one or two of your drawings. Sometimes the slightest of notations will suddenly begin to look like pictures. Generally, try to avoid having a strong element, whether horizontal or vertical, central in your composition, for you are now in the process of composing by relating your picture to a suitable rectangle. I prefer to compose from my drawings like this, rather than gaze at the world at large through a view finder (i.e., a rectangular hole cut in a piece of cardboard) which often results in rather trite pictorial ideas. Emotion can be truly recollected, even reassembled, in tranquillity, with a drawing framed with a movable edge. As you do this try to recall why you were seized with a particular starting point and see if your mode of composition can emphasize this.

I expect you have seen a reproduction of that self-portrait of 1890, the original now sadly lost, by Vincent Van Gogh as he sets out on a painting expedition to Tarascon in the south of France. It is a hot day, the painter wears his haversack containing painting gear, with folding easel strapped across the top – he carries a canvas under his arm. Even after a hundred years, the sense of expectation which we feel when setting off to paint still comes across in this picture. Many painters, myself included, usually prefer to work back in the studio from drawings and notes made on site, but there is no denying the pleasure and sense of challenge that a painter can feel when confronting a chosen view. Preliminary reconnaissance has pointed to some painting possibilities; now it is time for you to pack the paints and select a site, bearing in mind the position of the source of light.

I generally try to avoid painting with the source of light, probably the sun, directly behind or above me. This will invariably flatten the appearance of the chosen view. Light coming from left or right or even from behind the subject will probably offer more sense of space and atmosphere. Also pick a reasonably sheltered spot in which to set up your stool and/or easel. Shade from sun in a hot country is obviously a good idea to avoid sunburn and also the glare from a white canvas or board, which can disrupt judgement of tonal and colour values. In a damp climate a doorway or even a window may offer both vantage point and shelter.

Sketchbook study of church, note enlargement grid

Many less experienced painters feel some trepidation at the idea of standing in the corner of some foreign field or street or square while they work. Those who have been painting for some time know that, once this initial feeling is overcome and they become absorbed in their work, that very absorption will help to generate a sense of protectiveness amongst the locals, most of whom are really rather proud that someone has selected their area to paint. There will be those onlookers who persist in standing in front of you to watch while you work, blotting out the view; a gentle gesture should suffice to move them. Others will want to engage you in conversation. Harden your heart, concentrate on your work and reply not. Make it clear that your work as a painter requires every ounce of concentration – which it does.

First shapes placed as watercolour washes

Settled in front of my subject, a rapid tonal value study, indicating the position of the main source of light with an arrow, helps to establish the feel of the subject and the composition and reminds me of the position of the light when I started painting. Then on my canvas, or stretched watercolour paper, I place the silhouettes of the main shapes using pencil for a watercolour, ultramarine blue thinned with turpentine and applied with a brush if I am working in oils. I may well follow this with some preliminary broad washes in watercolour to establish the colour theme and build the sense of light. In oils I scrub on some initial areas of tone, using a broad brush and more ultramarine blue and letting the white canvas stand for the light areas for the time being.

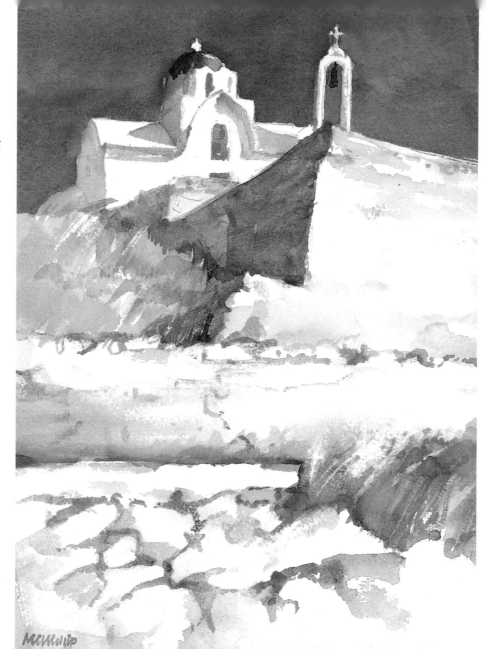

Watercolour based on a sketchbook study

My favoured group of six colours, two yellows, two reds, two blues has proved capable of dealing with the very wide range of subject, colour and light situations in many different countries. I find that the great advantage of such a limited palette, apart from simplicity and ease of carrying, is that one has to search for a *colour* equivalent in the dark parts of one's painting. Dull old browns and greys simply won't do – this applies especially in warm climates where there is plenty of reflected light in the shadows. Another virtue of such a limited palette is the sense of colour unity that it can bring to a painting. Above all the wise painter never attempts to work on site from the same viewpoint all day. Even in dull weather the light source position will change radically – an attempt to change your picture with it will surely bring a muddled, possibly muddy result.

First lay in, above (oil paint thinned with turpentine); and opposite, finished oil painting of El Jadida, Morocco

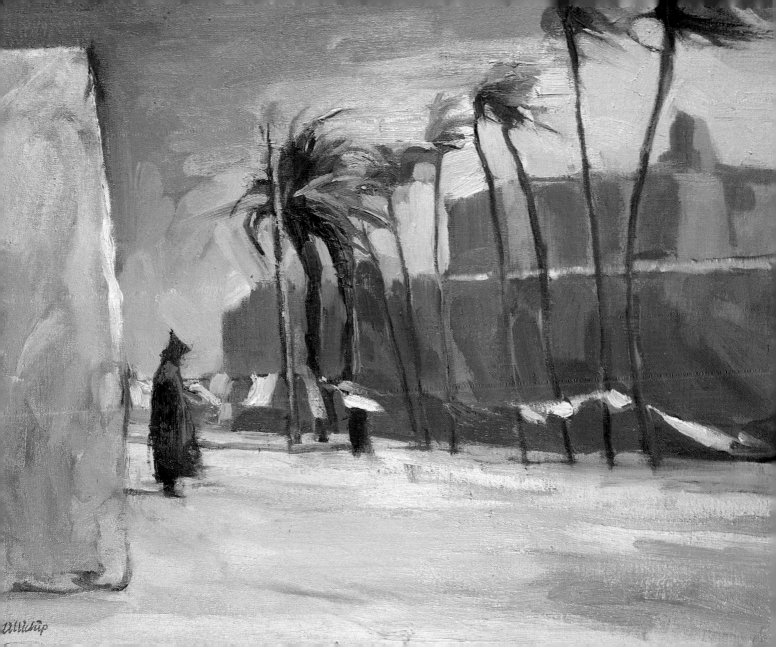

Painting, happily, is still a very personal activity, and there are as many different approaches to it as there are painters. A painter's approach might be said simply to work from the general to the particular. Large areas of colour go on first with say a sky or a large foreground, then I may change to a smaller brush to define smaller parts. After the first indications I try to avoid putting lines round things in my painting, preferring definition through areas of colour or tone. In an oil painting I tend to save the lightest parts until the last, enjoying using fairly heavily, impasted mixtures, which can be applied with some precision over thinner, darker, richer areas.

If you travel from a country where cold and damp prevail to a place with generally a warm dry climate, remember that everything will dry faster in that warmer climate – including paintings. Try to paint a watercolour on an absorbent paper on a dry day and your wash will be soaked up before you have a chance to let it flow across the surface. The answer is to use one of the more heavily sized and less absorbent papers such as Arches or Fabriano Rough. You can flood your wash onto this surface, using more water than usual and keeping your board slightly tilted as a precaution against unwanted ridges and blobs. In other words you will adapt your working procedure to your situation, not a difficult problem but certainly worth bearing in mind.

Oil painters will probably find the increased rate at which their paints dry in a warm climate helpful. If I am painting in oils in, say, Greece, Turkey or Morocco, I usually find that, provided I stop using my paints within a couple of days of going home and put my painting out in the sun, the surface will be dry enough for easy packing and transport. Remember though that hot countries are also dusty. I recall finally giving up as a bad job an oil painting of mountains in Crete when the *meltemi*, a violent local wind, suddenly caught my canvas and delivered it face down on to a pile of sand and straw. The result was an interesting texture but not quite what I had in mind!

Sometimes the weather can make a positive contribution. The damps of a northern climate have certainly aided many outdoor painters in their evocation of atmosphere. One thinks of Turner's mists but also, nearer our own time, of the German Emile Nolde, who delightedly used the crystallizing action of snow on his watercolours to evoke the moody part of Friesland where he worked.

The vagaries of weather and climate can offer other, sometimes unexpected, bonuses. Picture, if you can, a wet day on the Algarve coast of Portugal. The group of painters whom I have brought to southern Portugal feel rather cheated that their landscape painting has been interrupted, and dark looks are cast at me, the obvious miscreant! Hastily I visit the kitchen and talk the cooks into letting me borrow a pile of cooking ware, jugs and bottles which I duly arrange in groups on the covered terrace. The rich, varied warm browns of the local, handmade pottery provide a focus and inspiration for the painters, and 'still-life' day is proclaimed one of the most successful features of the course.

From my sketchbook

Greek Village in Strong Wind, *watercolour,*
15¹/₂ × 25in (39 × 64cm)
Dried grass of early summer lent fiery colour
to this view on a stormy day in Greece. The
angle of the wind-swept grasses made a
positive contrast to the buildings' verticals,
and I enjoyed myself splattering paint on the
foreground to help add movement to the scene.
Two days of windy weather made a fascinating
contrast to the usual brilliant sunshine – a
good opportunity for a painter! Colours
included Alizarin Crimson, Ochre and
Winsor Yellow.

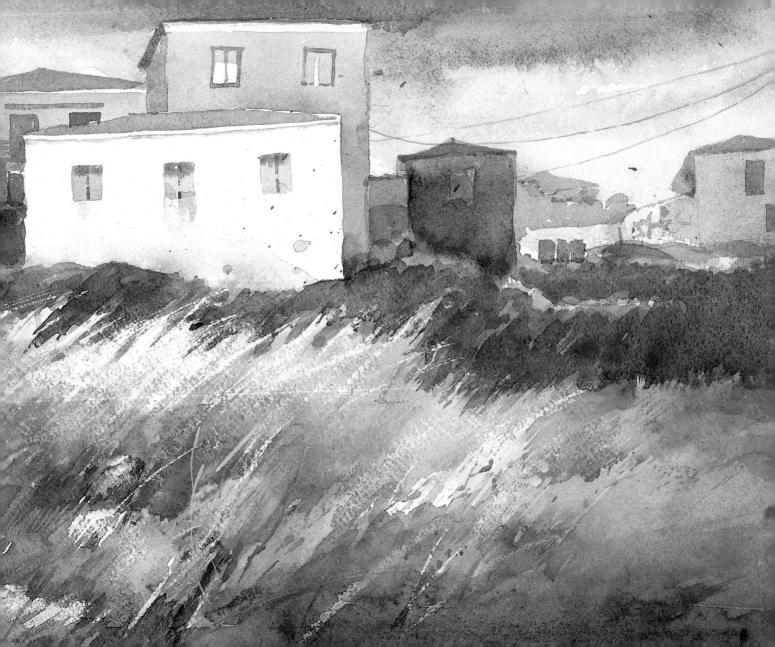

Again after a long hot spell in late autumn comes a stormy day on a visit to Greece. The painters are unable to work outside but, perversely, the weather clears in the evening and, by the time dinner is over, has settled and become warm again, so the group are invited to join me in a night painting exercise – an opportunity to add a new dimension to their tonal observations. The most unprepossessing of towns can take on a new mystery and beauty by night, and I often find that even the least extrovert of painters will be prepared to scribble or wash away with gusto to achieve the depths of dark required to make those harbour-side lamps or the café lighting appear brilliant enough by comparison. Paper prepared with a dark wash in advance may be useful here, as may charcoal, gouache or crayons. A flashlight will be a handy accessory too.

Harbour By Night, *watercolour and gouache, 10 × 14in (26 × 36cm)*
I like to start with a structure of darks for night studies: points of light can be added at varying intensities later to show street lights, windows and reflections at varying distances. Night studies are a good way of extending one's tonal comprehension.

Pembrokeshire coast, Wales. Rainy day study

76

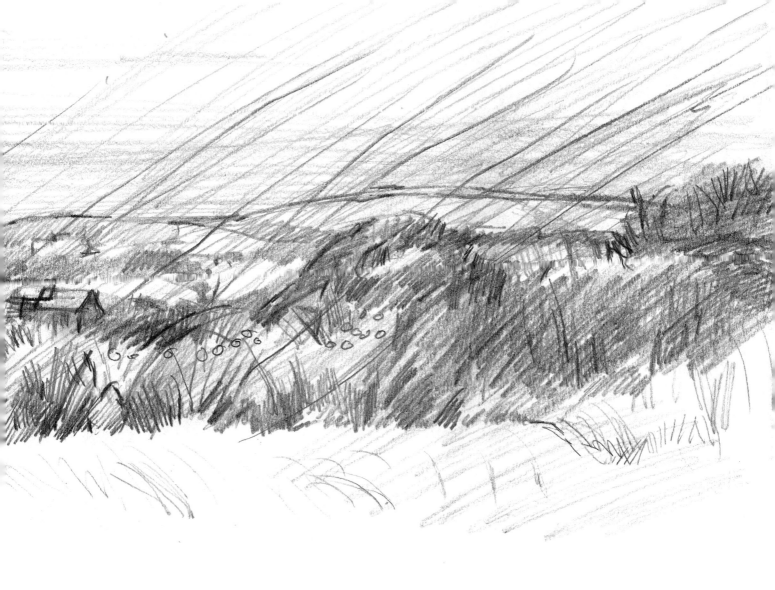

One further weather example comes from west Wales where rain is not so unexpected. We are in a stone built cottage that crouches into the hillside against the wind and rain that sweep up from the sea. Dark purplish clouds race along the horizon, and a veil of rain covers the mountains.

However, we painters are warm and snug in the cottage with the woodstove cracking cheerfully. We certainly have no intention of letting the weather stop us working. I place a bunch of brilliant chrysanthemums on a window-sill so that the glowing colours relate to the white painted cottage walls inside and the shifting greys of the rainy landscape outside – as ever the spur of a given situation leads to a group of fascinating paintings.

All travelling painters will have encountered situations similar to these and will have found their own ways of responding to them, indeed exploiting them, to the maximum painting advantage. For artists, as I have always maintained, are the most resourceful and buoyant of individuals.

Young artist to John Opie :
'What do you mix your colours with?'
Opie : 'Brains'

5
Excursions

Come to the Island of Cythera, in pilgrimage with us!

French song

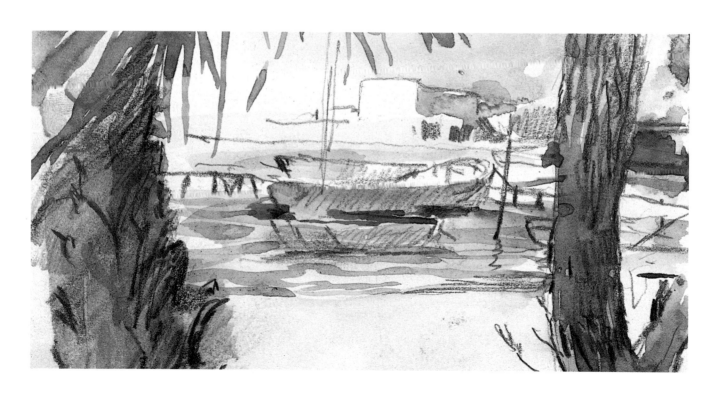

From my sketchbook

80

There is a lovely painting by Antoine Watteau in the Louvre in Paris called *The Embarkation for Cythera*, one of four versions that the painter made of this subject. The picture is an eighteenth-century Rococo representation of a group of exquisitely dressed people, ladies and gallants, strolling gently down to the waterside where waits an elaborately decorated barque ready to carry them to the distant misty island of Cythera. A dreamlike evocation of a day's excursion.

It has to be said that few real excursion experiences compare to that fragile quality evoked by Watteau, but I suspect that most of us would, in any case, prefer something a little less ethereal and more practical. Once you have established a sound personal base, you may well wish to spend a little time further afield enjoying a change of scene and an opportunity to take a wider view of the area. As with so many other aspects of travel the painters' approach to an excursion will be different since their requirements are different. Tourist sightseeing is certainly not at the top of the agenda. Perhaps like Watteau's elegant characters, you will be able to travel to some nearby island or bay, delighting in the play of light and reflection on the water as the boat chugs on.

Alternatively, you may journey out in a local bus or taxi, appraising the countryside as you pass by. In each case, the alert eye of the painter will be ready to make the most of the stimulation of a new scene.

From my sketchbook

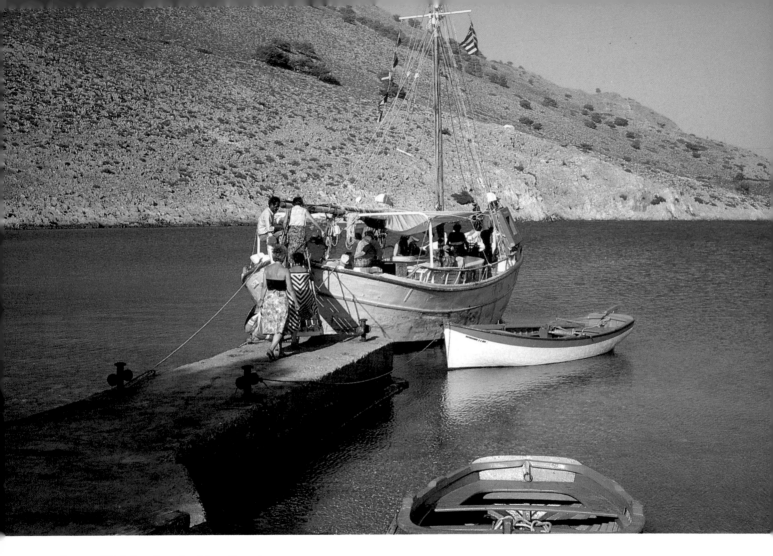

Group of Painters Leaving Marathounta
on the Island of Symi, Greece

Group on a Boat Excursion in Southern
Greece

Marathounta, Greece, oil, 20 × 36in
(51 × 92cm)
*From a drawing made on a stony beach during
a day's boat excursion in the Dodecanese.
Strong late afternoon sunlight reflected up
from the white stones of the beach and white
painted chapel. Painted using a mixture of
glaze and direct painting.*

When I am in a Moroccan town I always enjoy an excursion by caleche, the ubiquitous horse-drawn open carriage that is almost ideal transport for the painter, combining gentle and not too rapid movement with a perfect observation point for sketching. The driver can be asked to stop whenever a likely subject comes into view. However, probably the most perfect style of excursion for the painter is on foot, moving at a steady pace, enjoying the sights and scents of the landscape or townscape and keeping an eye open for a vantage point should some potential subject come into view. Watch experienced painters selecting a view and see the way in which they circle their prey before finally settling in the place that experience tells them will offer the quintessence of the view they have spotted. Remember that eye levels change radically when you sit down, and the view that looked so perfect when you were walking or standing may well lose its whole point when you sit down to draw. What kind of painting equipment should you take on such an excursion? As ever it should be light in weight and compactly carried in a shoulder bag. Clambering on and off boats and buses, especially in the company of eager locals, you need both hands free. I would recommend taking nothing more elaborate than a sketchbook, pencils and a pochade box, but if you are keen to paint a picture on site and can fit your drawing board or canvas into your bag, this may be worth while. Bring a sun hat in a hot country but leave behind if you can bulky equipment such as sun shade, folding chair and easel.

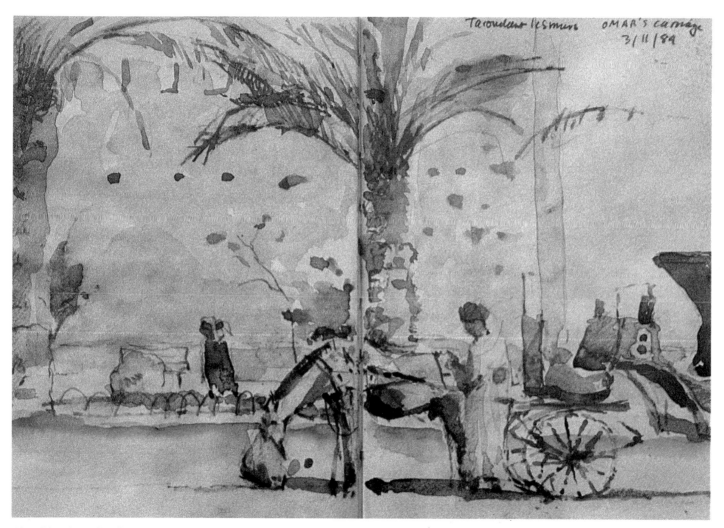

Sketchbook study of a Moroccan carriage

A student with lightweight painting and drawing equipment, working in a Greek village

When I am visiting a new area I like to feel a relative sense of mobility as I explore, rather than wanting to tie myself to one specific spot by sitting down and painting there all day. I well remember arranging a day's excursion by bus for one of my painting parties in southern Greece. On a hot morning we sat for some time in the bus waiting for the last member of our group to appear. She finally arrived towing a rather frail trolley loaded with enough equipment to make one believe she must surely be moving house. It was quite a problem fitting all this onto an already very crowded bus. When we arrived at the village that was our destination, this lady set herself and her equipment up in the village square and struggled with a painting of one view all day. Transporting her wet oil painting back in a crowded bus was another story! When that painting was shown at the evening meeting and critique which I hold for my painting groups, I felt that this same lady had gained less from out excursion in terms of information and atmosphere than those who had set out more modestly equipped but with eyes and minds more open and alert to a wider range of possibilities.

Many of my own excursions from bases abroad have been in search of some particular quality of light or colour rather than specific subject matter. A number of my watercolour paintings done over the last few years have been concerned with the movement of water and the action of light on water in warm southern countries such as Greece, the south of France and western Turkey. I have spent a good deal of time sitting on harbour walls and jetties, gazing down into the depths, admiring and attempting to record in my sketchbook the action of brilliant sunlight refracted off the water's surface and its relationship to the pattern of that light on the ocean floor. This obsession was then extended to the movement of swimmers through clear water and the reflection of moored boats in harbours – a preoccupation of this kind can certainly help to focus the painterly vision for a time on one aspect of the surroundings inevitably leading perhaps to greater intensity of vision, but I shall talk about the sea in more detail in Chapter 9.

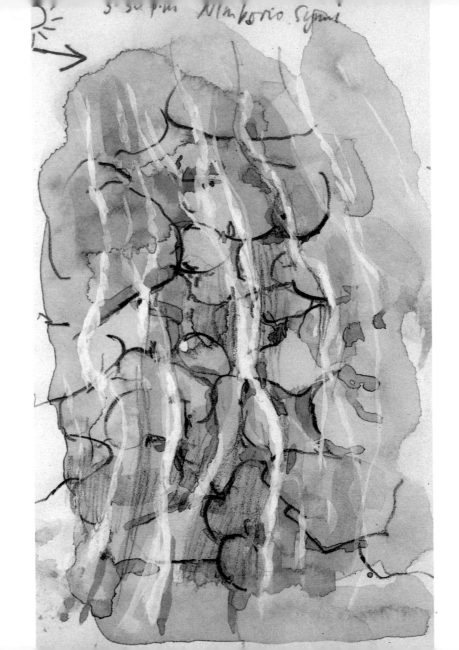

Studies of water in a Greek harbour

90

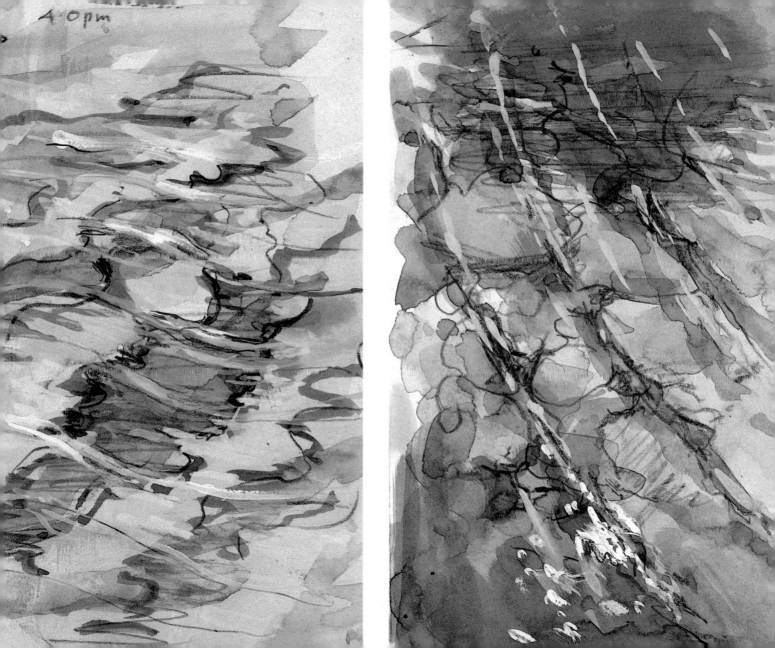

4.0pm

Aya Galini, *watercolour, 12$^1/_2$ × 22in (32 × 56cm)*
Swimming in a rocky pool in southern Crete. A series of transparent washes of French Ultramarine with Winsor Yellow superimposed to create greens. White gouache applied with a knife to make the crisp water highlights.

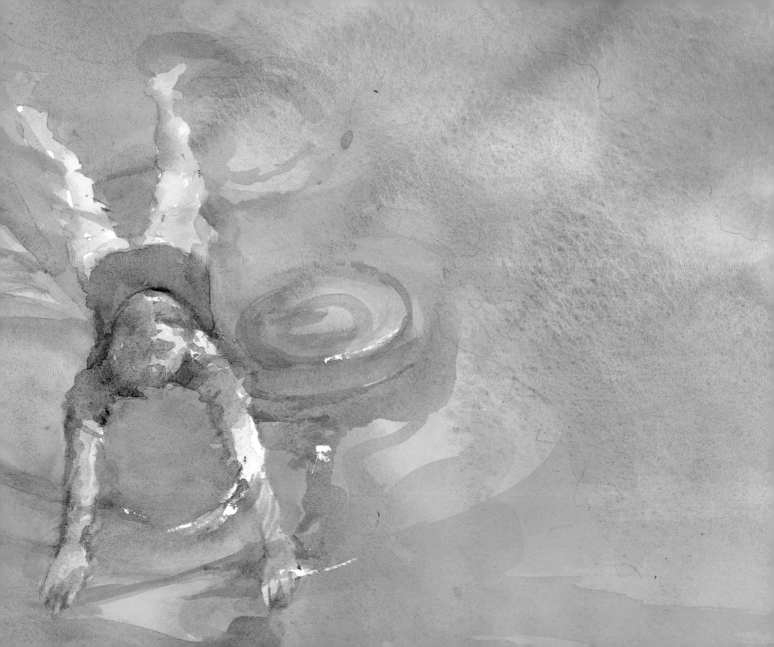

Agios Giorgos, watercolour, 12$^{1}/_{2}$ × 21in (32 × 54cm)

A beach reached by boat from Lindos, Rhodes, Greece. The dynamic movement of the water was as important as that of the figure in this painting, with a certain counterpoint provided by refraction lines on the water's surface. I used superimposed washes of Ultramarine to create the strong dark shade on the right. Succeeding washes have to be in pure, rather than mixed, colours if richness is to be retained. Some areas were modified with pastel.

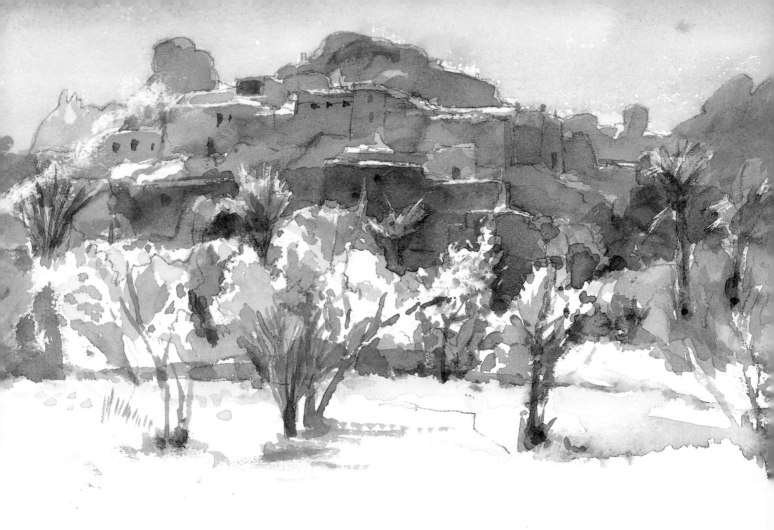

Minichip

96

Discarded wine jars

Tasga, Morocco*, watercolour, 10 × 14in (26 × 36cm)*
A foot exursion of about a mile from our room in the Ante Atlas Mountains. Painted looking into the sun one hot afternoon in February at the expense of a sunburnt nose! Washes of blue went on first to show the silhouettes of the rocks and almond trees. The washes dried quickly and I laid transparent Ochre and Cadmium Red over to show the mud dwellings which almost blend with the rocks. Light on housetops was scratched out; smoke on the left was achieved with sandpaper.

As a tutor I sometimes set a daily theme for my painting groups abroad when they make short excursions, and it is always fascinating to see the group members' response when asked to look out for and render, say, 'enclosed courtyards', 'shadows cast by stones', 'figures in conversation'; concentrating the eye and mind often yields a useful visual bonus. Indeed the set theme of 'rubbish' produced some of the most original paintings I have seen from my groups, ranging from an amusing drawing of a rusting and discarded tractor to a grouping of discarded wine jars.

Homer speaks of the seas around Greece as being 'wine-dark'. Dark they certainly are, especially as one crosses them in a small boat. Perhaps 'ink-dark' might be more precise – although not so poetic. On one particularly memorable excursion, these thoughts were prompted as our little boat spluttered along near the east coast of the island of Karpathos in the Dodecanese. Although small, the boat was well freighted with eager tourists, for this was to be the last round trip of the season before October gales set in. We were bound for the archaic village of Olymbos, enjoying a change of environment toward the end of a productive two-week painting holiday on the island.

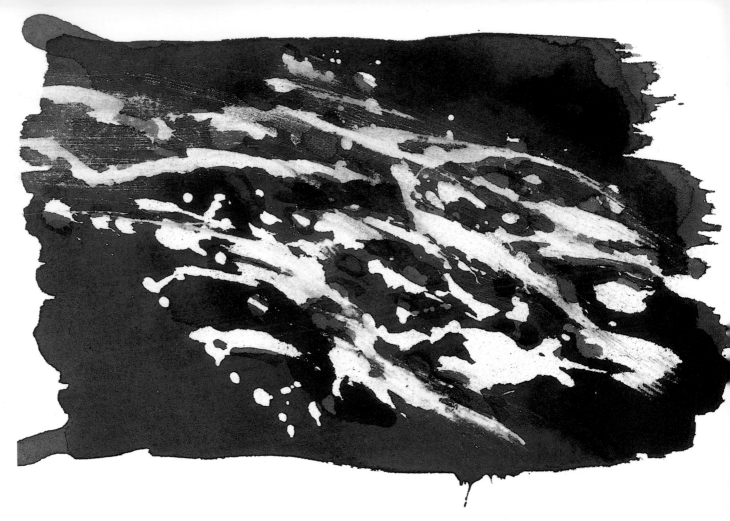

Painters are always painting even if they have no canvas or paper in front of them. 'How would I paint that in watercolour?', I ask myself,

as I look over the boat's rail at the patch of white, frothy wake on that ink-dark sea. Answer: 'With watercolour, masking fluid flicked

Notations of sea patterns made during the journey to Olymbos by boat, watercolour

98

or thrown at the paper, allowed to dry, topped up with a rich wash of ultramarine, Winsor Blue and a little Alizarin. Masking fluid removed, patches of white shaped a little with a brush and given movement with some sandpaper when dry.' Try it next time you are on a boat off Greece! Landward, those ochrish cliffs reflected in the rippling water make a wonderful colour note. I use a fluid movement of a pointed sable brush to knit blue ripples over a varied ochre base.

After a couple of hours the boat pulls into the colourful little harbour of Diafani. As ever, my subconscious painter's eye is assessing relative tonalities as well as colours. Just how dark is the purple-blue sky of noonday Greece? Invariably darker by far than either whitewashed or netural stone house fronts. Mentally I again reach for Ultramarine, Winsor Blue and Alizarin and reflect that blue is surely the keynote colour of Greece, emphasized by the prevalence of blue paint on doors and window frames.

Disembarking, our group watch, fascinated, as bread is baked at an open-air wood-fired oven near the quayside. I make a quick sketchbook note of the oven and the movements of the two women in local costume who are using it. A rapid drawing records the essential silhouettes of the stocky figures as they work.

By now some of the ladies in our group have bought traditional Greek headscarves and a party of slightly inauthentic Anglo-Greek peasants boards the dusty bus for the mountains and Olymbos. If you go to Greece you collect many Greek signs in English, *'To marvelous veranda ten minutes by feet'* we notice as the bus leaves the village.

Bread ovens at Diafani, Karpathos, Greece

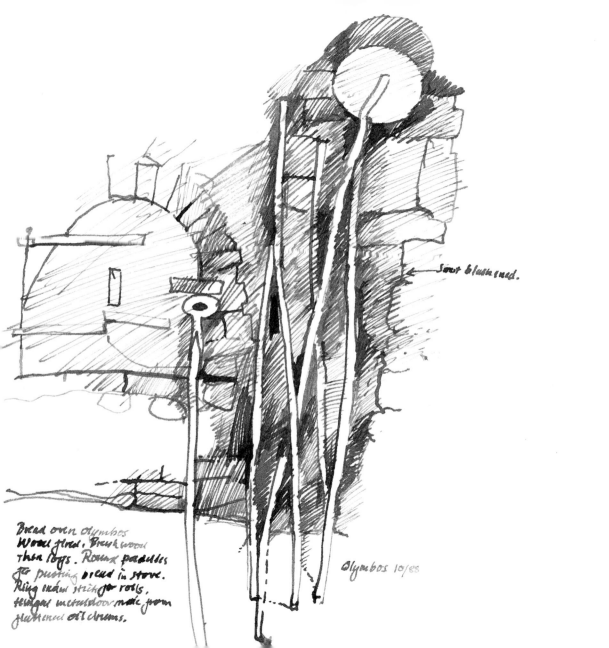

Soot blackened.

Bread oven Olymbos
Wood fired. Brushwood
then logs. Round paddles
for pushing bread in stove.
Ring round stick for rolls,
Bulgur metal door made from
flattened oil drums.

Olymbos 10/88

A precipitous drive with ever more acute hair-pin bends brings us to Olymbos, the village sprawled incredibly along a sharp mountain ridge by the sea and spilling down into a fertile valley inland. We book overnight accommodation, eat a lunch of stewed goat and macaroni and set out to explore this extraordinary place that offers a glimpse of a pastoral Greece from the past, a way of life that is disappearing fast.

The women, who largely keep the village running, still dress in the old costume of black and white with headscarf and intricately embroidered apron. Their beautifully decorated boots are made by the local cobbler. Built as it is on a ridge, the village affords strong and dramatic contrasts of light and shade, a chance to get out our soft pencils and charcoal sticks to render the dense shadows of the deep valley on one side, the brilliantly sunlit buildings against the sky on the other. On the very peak of the ridge, facing the sea beyond, is a row of stone-built windmills; the canvas sails of two of them are turning, grinding flour for bread-making tomorrow. Down in the land-locked valley the wheat is being reaped and threshed to be brought up in sacks on the women's heads for grinding in the mill. The picture before us is like a page of mediaeval history from a school textbook. We painters are ecstatic.

Olymbos in Karpathos, Greece, *watercolour, 10 × 14in (26 × 36cm)* *The remote village spread along a mountain ridge at the end of the island of Karpathos: developed from a tonal drawing made in late afternoon on site.*

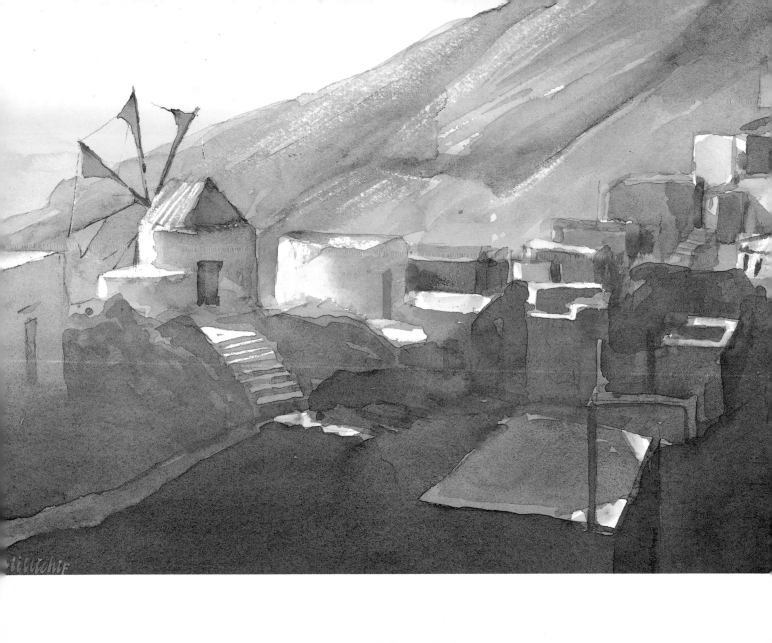

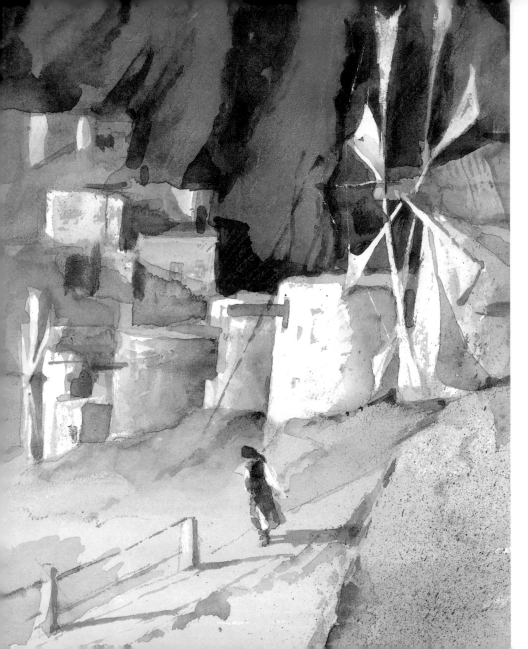

Next day, cock-crow and dawn bring more delights. Jonathan is already sitting on a parapet, recording a sunlit panoramic view in the lower village, showing his usual skill in selecting essentials and looking for the grouped shapes of buildings against rocky hillside. Ann has completed a drawing of the church belfry and is now busy with a transparent rendering of the windmill sails against the sky. Near her, two local women chatter in their dialect whilst busying themselves with Friday baking; the fragrance of fresh bread mingles with woodsmoke. Further along the ridge Margaret wrestles with the problems of rendering a receding row of windmills. I suggest that she looks for the shapes of sky between their silhouettes; drawing those shapes should help to counter her conceptual approach. Just beyond the ridge Pam finds herself involved with the problems of a sunlit wall against an intense blue sky with an immensity of sea

Mills at Olymbos, *watercolour and pastel, 14 × 10¹/₂in (36 × 27cm)*
The ridge from the seaward side with a line of mills, two of them in working order.

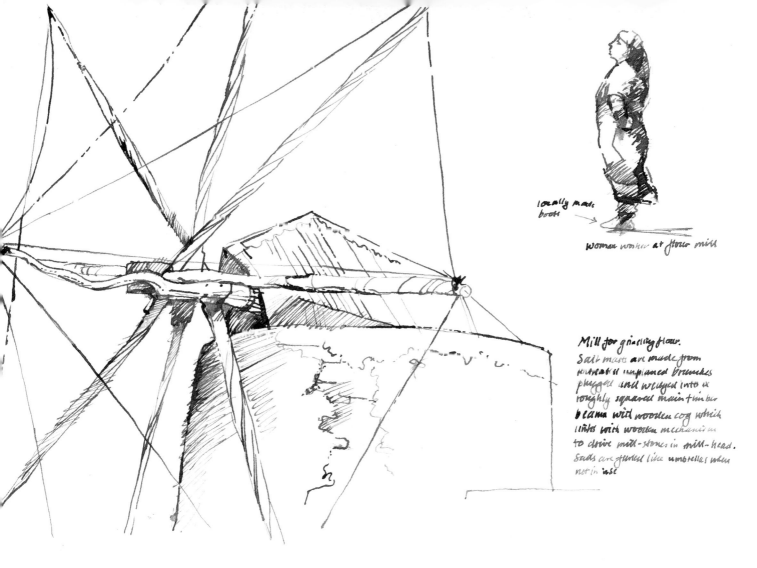

locally made
boots

Woman worker at flour mill

Mill for grinding flour.
Sails are made from
numerous unplaned branches
plugged and wedged into a
roughly squared main timber
beam with wooden cog which
links with wooden mechanism
to drive mill-stones in mill-head.
Sails are furled like umbrellas when
not in use

From my sketchbook

beyond – a daunting prospect. As ever, the concern is to render the texture of the wall without losing its simplicity as an abstract shape. Sparing, yet suggestive rendering of texture seems to be the answer, requiring some careful thought about the nature of surface.

In Olymbos every visual revelation is so extraordinary that we find we can hardly relate it to the familiar, a truly refreshing experience for the painter and one appreciated by the group. On our return and during the evening critique and discussion of the day's work, it becomes clear that the visit to this unique site has proved to be valuable, not simply as an encounter with something strange but as a spur to looking anew at the more everyday world.

Upper Town, Olymbos, *watercolour,*
10 × 14in (26 × 36cm)
Houses built at the top of the sheer rock face in
the village.

From my sketchbook

6
Observing close up

It is not sufficient that what one paints should be made visible, it must be made tangible.

Georges Braque

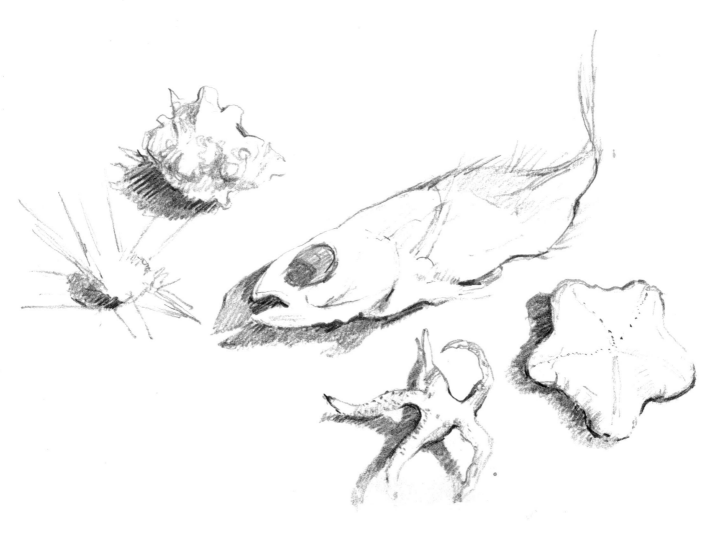

A hot afternoon in a small Greek village. After a good lunch I am sitting comfortably in the shade; the will to paint is faltering a little. I notice a group of shells, dried fish and sea urchins that someone has brought in and strewn onto the edge of the terrace. The sharp shadows cast by the afternoon sun give immediate significance to these objects, this holds my interest and I begin to draw – a drawing that develops into a watercolour painting and a record of the brilliant light of that afternoon.

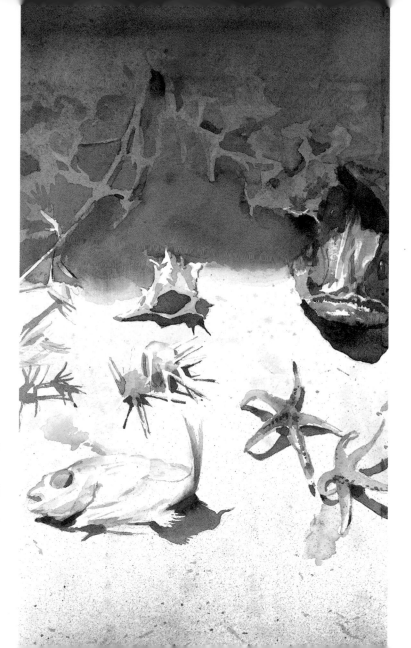

Aegean Marine Life, *watercolour, 21 × 11in (55 × 29cm)*
The sunlight was so brilliant on these brittle, dried fish and shells that the shadows appeared to have more substance than the objects themselves. I used very fluid paint to make the cast shadows, aiming at maximum density combined with transparency. A little splatter work was used to suggest the texture of the foreground.

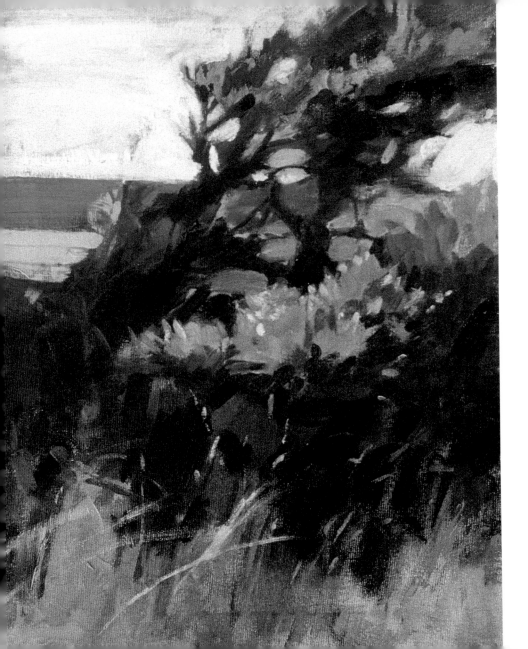

On a cold windy morning in west Wales I decide to turn my back for once on dramatic views of the sea and sky with their ever-changing light and concentrate on the form of a thorn bush, tortured by the prevailing wind into a strong diagonal shape and close by the door of the cottage where I am staying. A small oil study recalls the soft light of Wales and the wind-shaped growth against a patch of brilliant sea.

Study of Hawthorn, *oil, 16 × 12in*
(41 × 31cm)
Painted in two stages. First stage was a blue underpainting well rubbed into the canvas; dark greens and violets for shadowed areas went on next; and small touches of thicker paint showed light catching leaves and grasses. Sky colour was used to sharpen the tree silhouette afterwards.

Enjoying a cup of coffee on a bright morning in Barcelona, I look across the street at a large shadowed door shuttered for the day – '*Magic*' is the word that emerges from the shadows. Out comes my sketch book to record this enigmatic door with its mysterious message. It is a night club entrance.

How easy it is to ignore the obvious in the search for a starting point for a drawing or painting. Often the subject that is close at hand can lead to fascinating beginnings. Since you are a painter you will especially enjoy the view from the window wherever you stay. I can recall the delight of seeing crowds of brightly coloured kites flying when I looked out of my hotel window in Colombo, Sri Lanka. A pension window in Florence presented a roofscape of pink pantiles. Paris offered those famous grey mansard roofs, Rome some eccentric chimney pots and so on – visual riches close at hand for the traveller with eyes to see.

Try looking at that view outside in relation to the window frame itself, perhaps using the glazing bars as an integral part of your drawing.

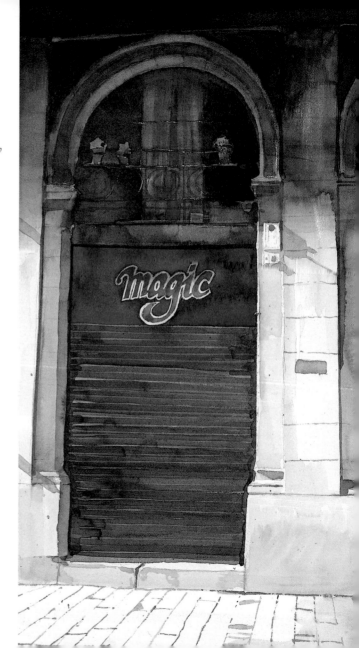

Magic Door, Barcelona,
watercolour, 29 × 15in
(72 × 38cm)
I deliberately aimed for intense darks at the top of this picture to emphasize the enigmatic, mysterious atmosphere and show up the light reflected from the ground. A good deal of information was suppressed, especially in the darks, to make a more positive image. Dark areas were mixed from Alizarin, Winsor blue and Winsor yellow.

Some likely shapes will begin to reveal themselves and the limitless sky will come into place as part of an organized design. Tonally, the window frame will almost certainly be stronger in value than anything else in your composition, yet if the light is intense outside there will be interesting reflected light inside. Now try placing some positive shaped objects, say a plate with some fruit on it and a bottle, on a window-sill or table in front of the window. See how the shapes of the objects inside echo or complement aspects of the view outside – the roundness of fruit sets off the squareness of buildings – the vertical line of the bottle echoes a tower or chimney. Exciting possibilities begin to emerge for making a picture. Your would-be idle afternooon suddenly becomes very busy!

When I stay near the sea I like to set groups of objects on a parapet or balcony and use the sea itself as a a backdrop. I found some pot shards near the villa we were using on a Greek island and set these out in the sun to test how they could

relate formally to the line of cliffs on the other side of the bay. The masts of anchored boats added a vertical

Shattered Amphora, Lindos, watercolour, *10 × 15in (26 × 38cm), and study (above) The precise, sharp quality of Greek island light can make objects a mile away look as clear as those which are near at hand. In early afternoon cast shadows have a positive blue violet colour, which strongly complements the clear yellowish light.*

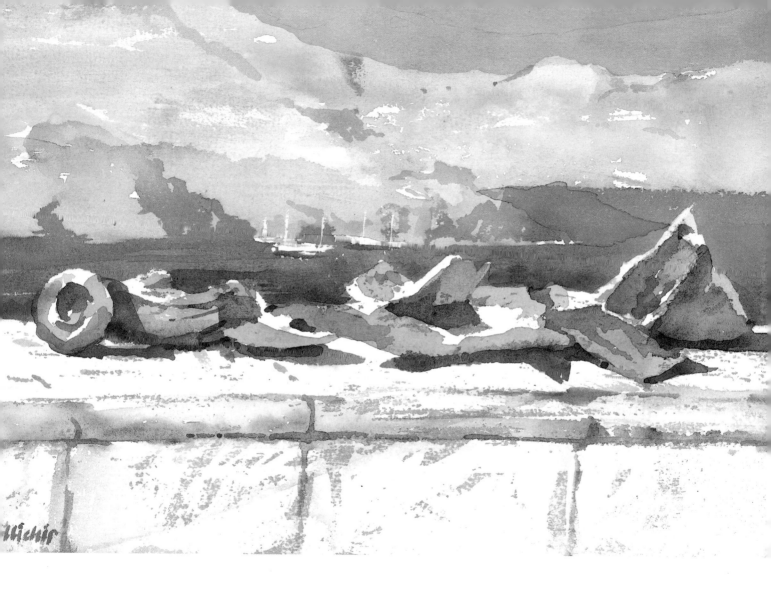

note. The jewel-like colours of fruits in brilliant sun against the sea will again offer a challenging study. How to integrate the intensity of those pomegranates and oranges with their equally intense surroundings and, as ever, how to render the colour and strength and shadows under a hot afternoon sun? The answers to these questions can provide a rewarding study for the travelling painter who wishes to change focus and look closely for a while at things nearby.

Pomegranates and Oranges, *watercolour, 10 × 15in (26 × 38cm), and study (above) Relating the fruit to their outdoor setting needed washes, which required adding some sea colour into the fruit and fruit colour into the mountains.*

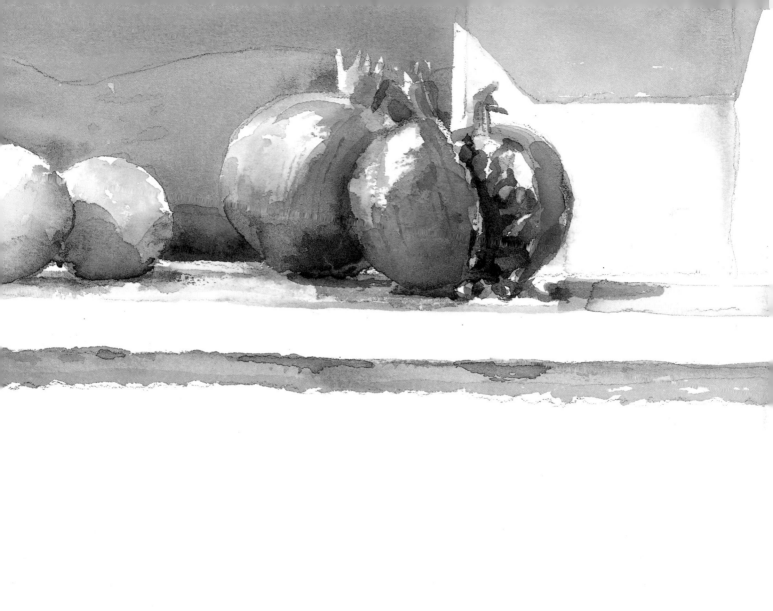

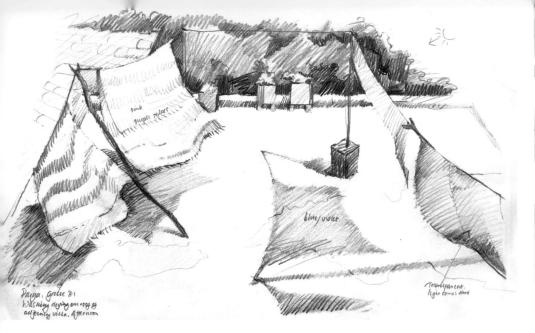

As you become aware of the daily pattern and rhythm of life in the place where you are staying, you may well notice certain everyday objects and activities that can prove fascinating and interesting to draw in close-up. I liked to see the brightly coloured washing hung out daily on an adjoining village roof-top. The lines were strung from poles set in concrete-filled oil drums and the clothes cast crisply transparent shadows on the flat roof-top. I noted the fascinating scene in watercolour.

Clothes on a Rooftop Line, Parga, Greece,
watercolour, 11 × 16in (26 × 39cm)
A quick afternoon study preceded by a tonal
note (above) in pencil.

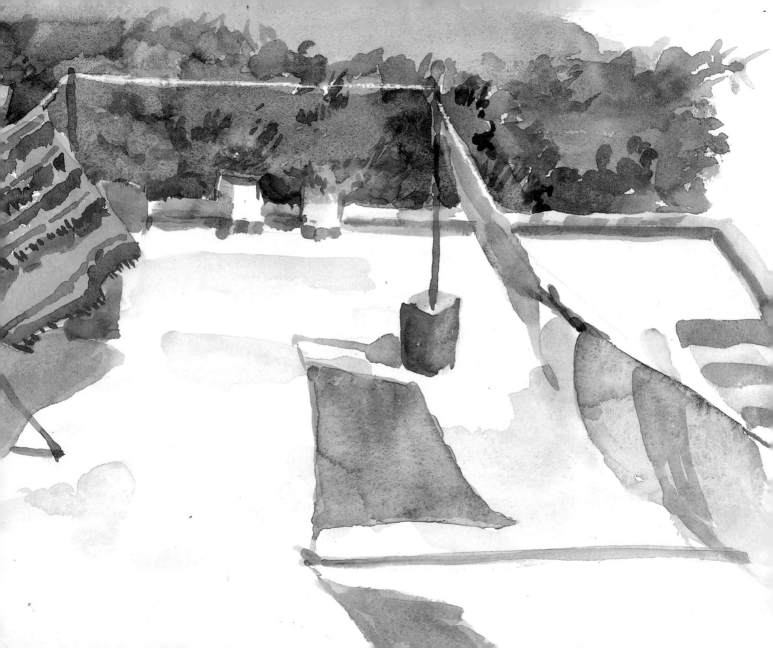

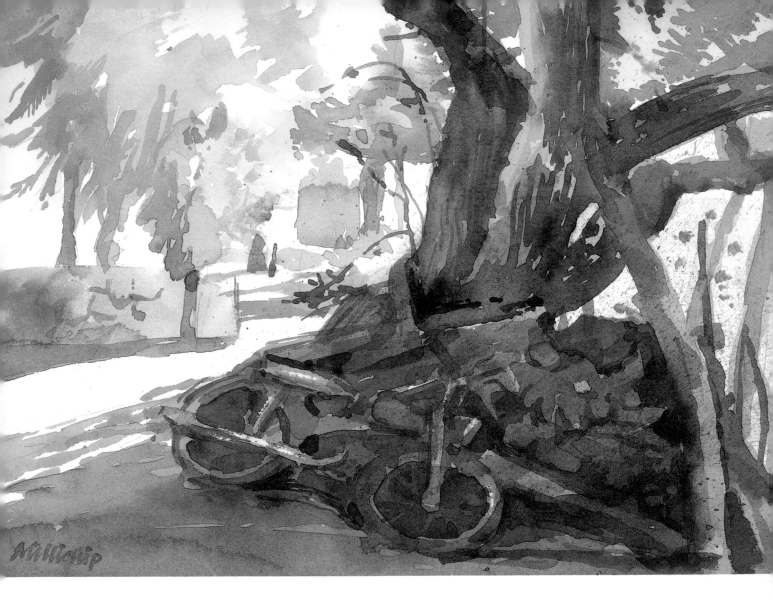

On another adjoining roof home-made goat cheese was laid out in rows of wicker baskets to dry in the sun, subject of a further note in my sketch book. Discarded objects and rubbish of all kinds can often create what I like to call outdoor still-lifes, strong light and deep shadows lend special interest to such groupings. I made a quick watercolour note of a rusting motor bicycle amongst other junk in deep shadows under an olive tree. As I painted I recalled that sculpture of a bull's head made by Picasso from a discarded racing bicycle-saddle surmounted by curved handle bar horns. Picasso said he would have been amused if a bicyclist had reclaimed the bull's head sculpture and returned it to its original use as a bicycle-saddle. Perhaps junk is best recycled as a painting or sculpture.

Discarded Motorcycle, *watercolour, 9 × 12in (22 × 31cm)*
The objects were just discernible in the olive tree shadow, needing the full depth of tonal range to express the brilliant light on the path beyond by contrast.

Doorknocker, Lindos, *watercolour, 20 × 11in (55 × 29cm)*
A shadowed hand of Fatima on a door with a dried bunch of flowers left over from the May flower festival. All the browns were mixed using Cadmium Red, French Ultramarine and Winsor Yellow with a little Alizarin Crimson and Winsor Blue added later for dark accents.

Prickly Pear, Greece, *watercolour, 14 × 21in (36 × 54cm)*
The sculptural shapes of prickly pears show well in Greek light but are difficult to integrate into the organization of a painting. I used an initial underpa
of blue to relate the plant to the sky and other elements in this watercolour. Greens were created with washes of Yellow Ochre and Winsor Yellow over t
base.

As well as keeping yourself open
and aware on your travels to the
painting possibilities of things close
at hand, never forget your own
front-door step. I looked down the
drive to my house one October
morning and saw a familiar daily
scene given a special quality by the
misty morning sun. Having just
returned from travels abroad, I was
able to see this same scene with a
new eye – travel doesn't just
broaden the mind, it sharpens it as
well.

To see a world in a grain of sand,
And a heaven in a wild flower
Hold infinity in the palm of your hand
And eternity in an hour.
William Blake

Study for **Parsons Close**, *overleaf.*

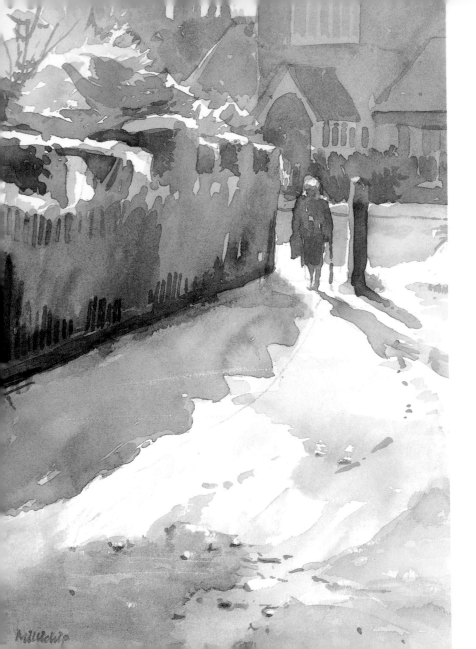

**Parsons Close, Winslow, England –
morning,** watercolour 14 × 10in (36 × 25cm)
*Slightly misty October morning sunlight
prevailed as I looked down my drive. I
originally intended this as a landscape-shape
picture but decided that portrait-shape would
make more of the shadows. Underlying blue
helped to create the atmosphere with pale
Alizarin overlaid to make warmer areas.*

7
People

Oh! I must somehow manage to do a figure in a few strokes.

Van Gogh

Whether or not you agree with Alexander Pope, that 'The proper study of mankind is man', you will certainly want to take some note of the people seen on your travels, if only to provide human interest in your paintings. Besides the many opportunities which a voyage can offer for the study of those who are travelling with you, even more exciting possibilities may present themselves when you arrive, settle in to a different environment and begin the study of people from *inside* the community. Consider in a little more depth some of the good reasons for including figures in your paintings.

Taroudant Street, Morocco, *watercolour,*
16 × 26in (41 × 70cm)
Constructed from studies made from a window
vantage point: some pastel was used to
enhance the transparency of the large shadow.

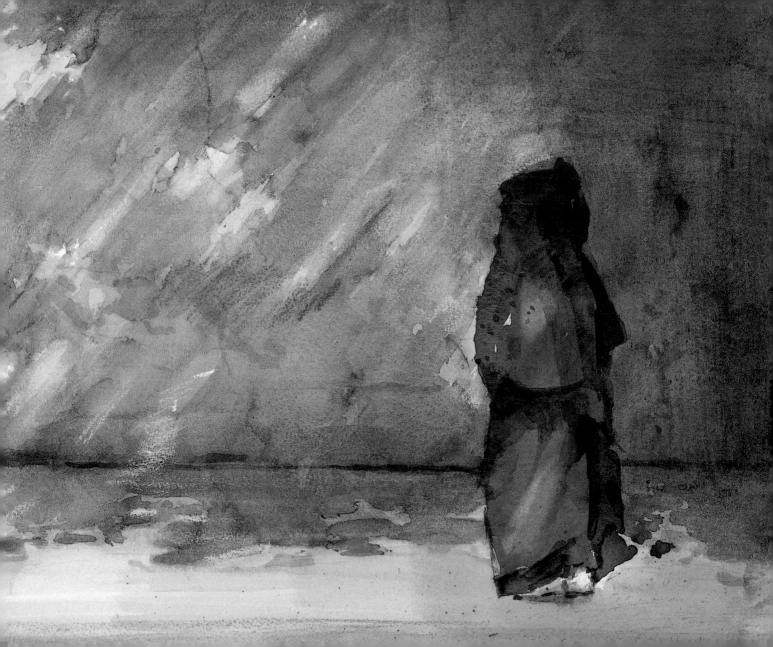

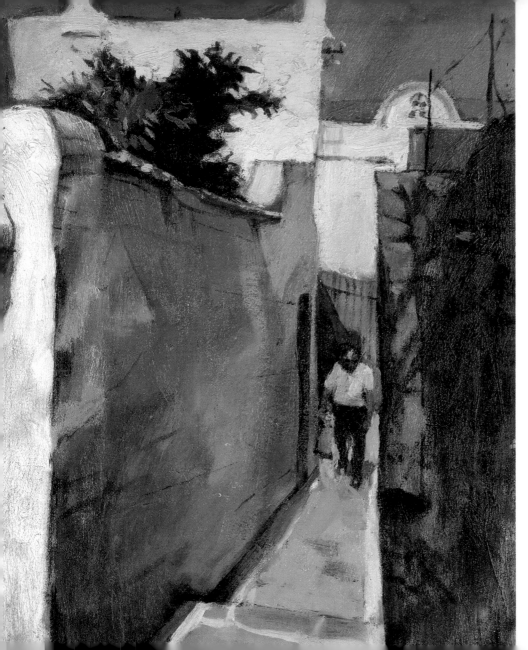

First, scale; well-placed human figures related to their surroundings can convey immediately a sense of whether the locale you are portraying consists of palaces or cottages. Take account also of the sense of life and movement that figures may give to an otherwise mundane view. Think, too, of the valuable contribution figures make to the colour scheme of a painting, introducing a note, perhaps, of a lively complementary colour. Possibly most important is the fact that most of us identify readily with our own human image and can immediately feel a sympathetic relationship with people in a picture, however slight the presence.

Upper Town, Symi, *oil 20 × 16in (51 × 41cm)*
In the narrow lanes, whitewashed walls reflect light in brilliant sun. The yellow tinge in the left-hand shadow came from an ochrish wall opposite. The figure was placed to imply scale.

Lindos Chapel, Greece, *oil, 30 × 14in (77 × 36cm)*
Figures were used to give a sense of scale and distance in the composition where space could otherwise be hard to read. The painting was built on a series of glazes, thinned colour, over an initial white underpainting with some opaque oil paint dragged and scumbled on afterwards.

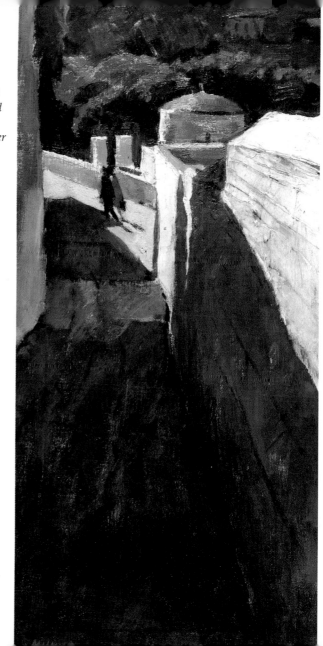

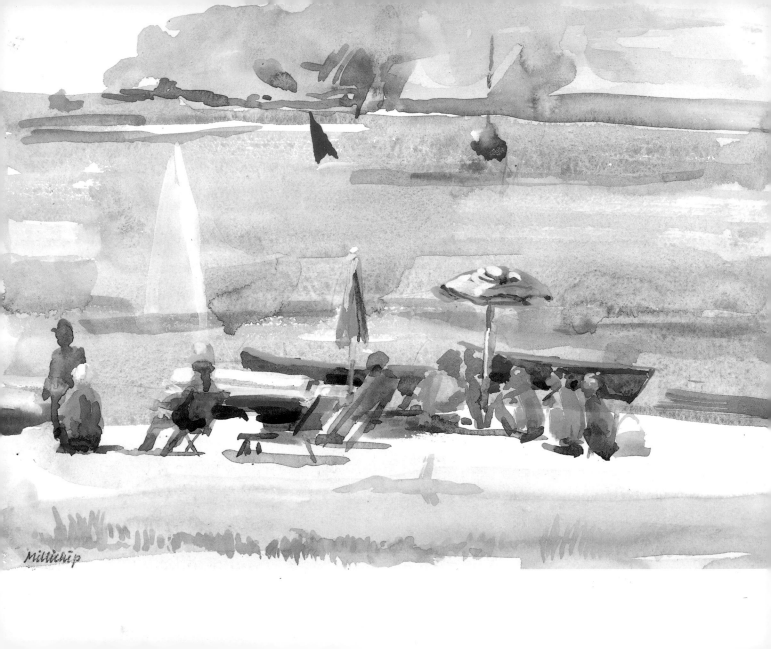

In order to record and observe people around you, your small sketchbook will be useful together with a fairly soft pencil, say 3B. I have always found that places where people naturally gather and sit for a while, such as cafés, and parks, give me a good chance to watch and draw fairly unobstrusively.

If you look at that woman over there, crouched over a cup of coffee, you will see that she presents a certain angular shape against the window behind her. Go for that overall shape or silhouette, not concerning yourself too much with her features or details of clothing unless you have time to do so. Practice putting down your notations as characteristic shapes, in this way, using shading to show figures as light against dark or dark against light. If you keep your drawings quite small you will soon find you can make notes of figures very quickly before they move.

Valtos Beach, Parga, Greece, *watercolour, 10 × 14in (25 × 35cm)*
A quick note on site, as I attempted to capture the afternoon light on a popular Ionian beach.

From my sketchbook

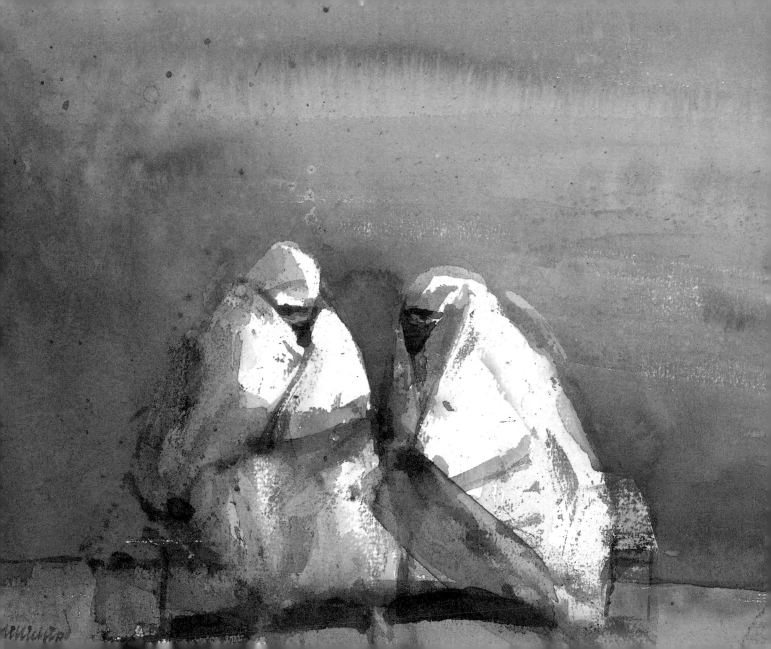

Now move on to a park or village square in warm weather. People will be sitting on benches. Select a bench some distance away and try to put down a shape that portrays the heads and shoulders of two or three people at a time as they are sitting on the bench, differentiating their character by their overall shape. Try to avoid making them look uniform like pegheads or skittles!

With the confidence gained from this kind of drawing, you may feel ready to station yourself at a convenient vantage point, in a car perhaps, and draw groups of people standing and talking – a market place is a good site for this kind of work. Try to put down a complete group of chatting folk as a single shape: from this you may perhaps graduate to figures in action, walking, waving, shaking hands, gesticulating as they talk. It

is not until you begin to record the range of gestures of people in different countries that you realize how the characteristic movements vary from one country to another. Of course the overall shapes of people vary tremendously too. In cold countries, bulky clothes will make for rounded and padded silhouettes while further south, in warmer places such as north Africa, the shape may well be that of a robed figure with a turban or pointed hood. Wherever you travel enjoy watching and recording your fellow men and women in your sketchbook and observing the ways in which their silhouette shapes differ from those in your own part of the world.

Conversation, Morocco, *watercolour, 13 × 21in (34 × 54cm)*
From sketchbook notes. The heavily-robed and veiled figures still contrived to look animated as they gossiped on the street-bench against a pink town wall.

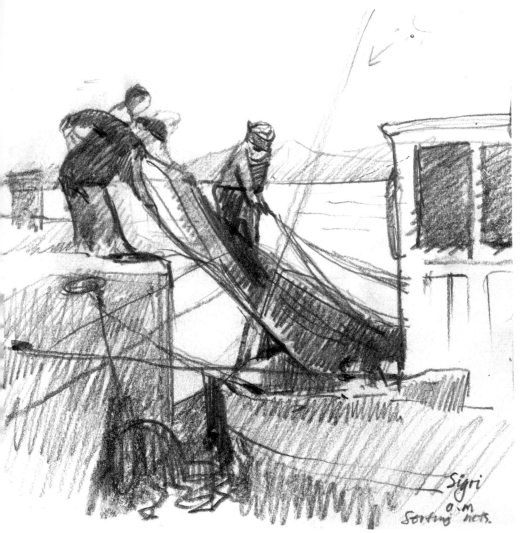

Sijri
a.m
Sorting nets.

People at work are always fascinating to watch and record, if the work entails some kind of movement with repetetitive physical activity, say unloading fishing boats. Watch for a repeat of an arm or a body movement that can be registered as a precise shape. If group work is in progress, one movement will complement another, and a certain work rhythm will start to appear. People playing sports and games, from garden shuttlecock to tennis, football to bowls will give you an ideal chance to study figures making specific actions. Bowls or petanque may indeed be a good place to start, without too many fast or violent movements, next graduate to football or tennis! From such beginnings many possibilities for pictures emerge.

Sketchbook study of fishermen

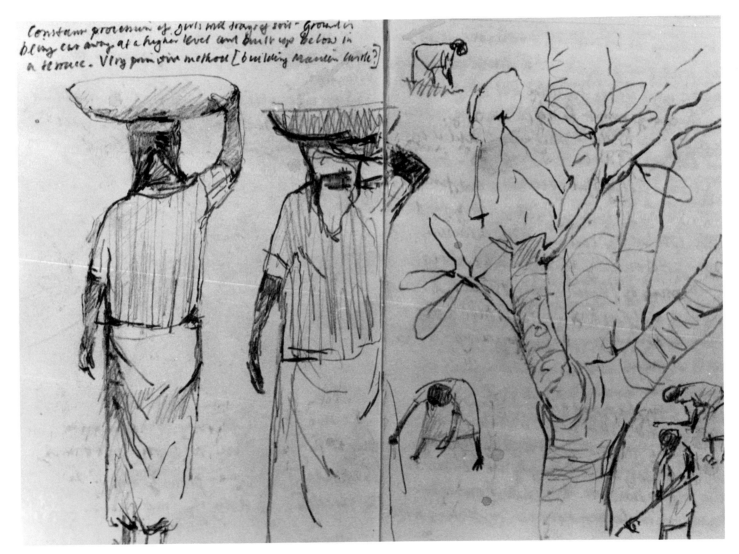

Constant procession of girls with trays of soil. Ground is
being cut away at a higher level and built up below in
a terrace. Very primitive method [building Maureen castle?]

135

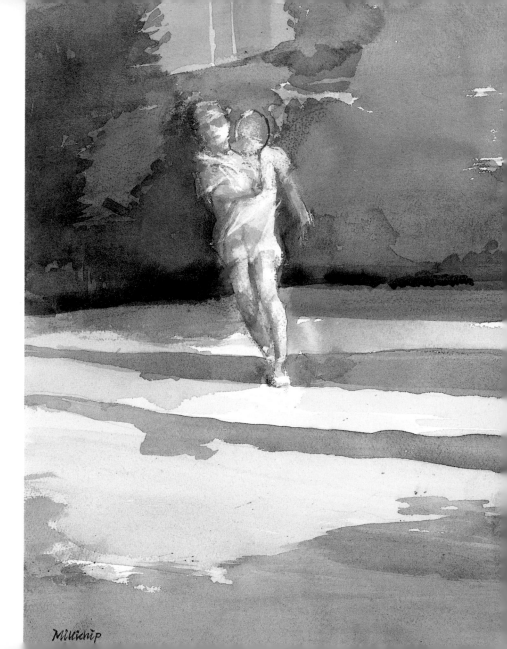

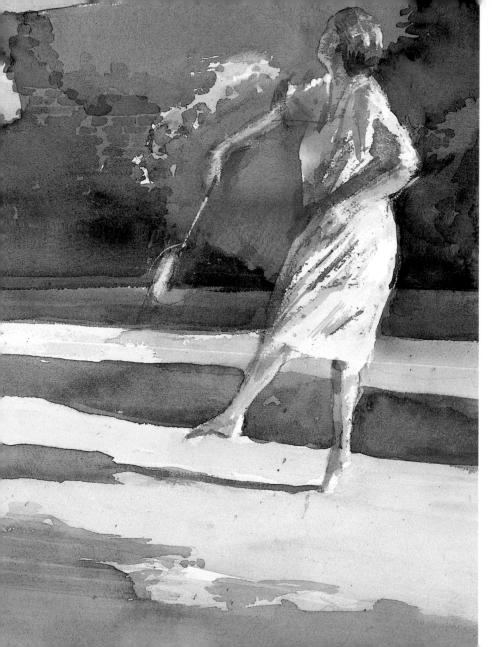

Garden Shuttlecock, *watercolour, 18 × 27in (45 × 69cm)*
Long, late afternoon shadows in an English garden gave structure and some atmosphere to this painting. I started with a very wet underpainting in Winsor Blue with Ultramarine, laid over a few indications of the figures in masking fluid. Washes of Winsor Yellow with a little Ochre and Alizarin helped to add summertime warmth and created greens. A little chalk was added to accent the figures.

Rooftop Portrait *(overleaf), watercolour, 11 × 28in (29 × 69cm)*
The walled flat rooftop of a Portuguese villa with the view of a windswept countryside beyond. The figure gave a useful pyramidal opposition to prevailing horizontals.

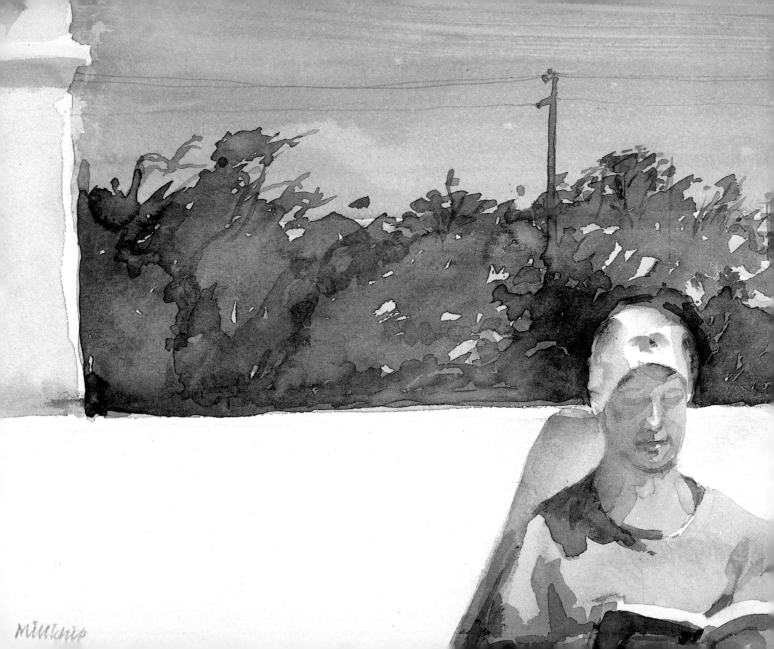

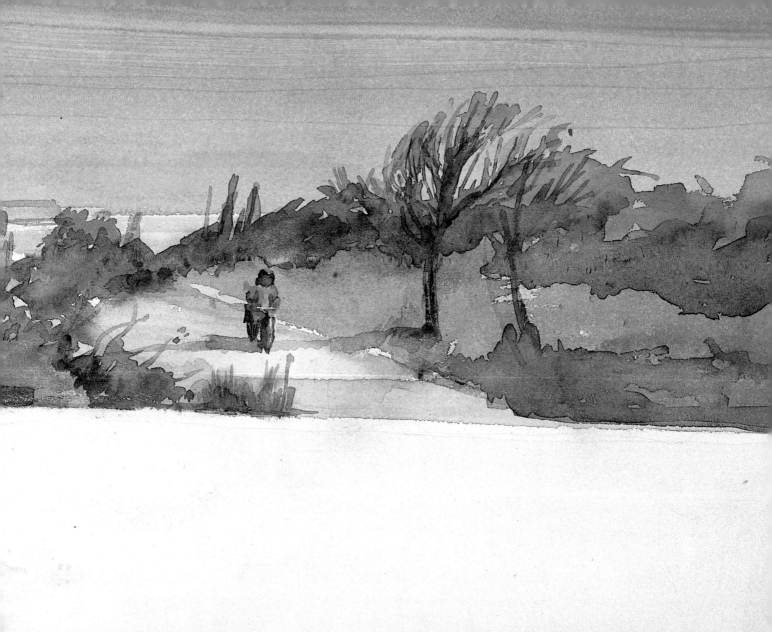

If you are staying for some time at one place during your travels, do consider the possibility of persuading one of the local people to sit for you. I have found that when word gets around that one is an 'artist' a request will often come for a portrait to be painted for the family. If you are prepared to give a little time to this there should be an opportunity to make some preliminary studies that could prove much more valuable to you than the finished piece. The people of Muslim countries are often reluctant to be drawn, but in most European countries, natural vanity and curiosity usually prevail over inhibitions. A student on one of my courses in Greece persuaded an incredibly piratical looking olive-press worker to pose for a portrait on the terrace of our villa. The swarthy, bushily-moustached figure with his rolling eyes and black olive stained clothes made an unforgettable contrast to the

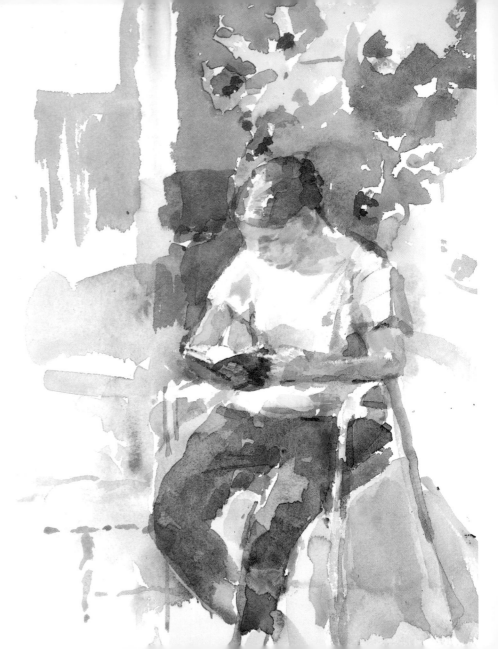

Rachel Reading, watercolour, 14 × 10in (36 × 26cm)
A rapid on-the-spot notation drawn with the brush on a warm afternoon in Greece.

precise blond figure of my student – an enterprising character since she had thoughtfully placed a bottle of wine at his elbow to keep him cheerful while modelling!

Look to the lead of the Masters when you make studies of people. In the figure drawings of Rembrandt you will see how his observation of folk in everyday situations performing everyday tasks is the key to the humanity that runs through his painting; two women support a tiny child's first tottering steps, a crippled beggar holds out his hands, a woman gazes dreamily from a window, Saskia sleeps in the curtained bed. Such 'snapshots' of mundane life are integral to the development of the painter's art; even if you feel the skills of Rembrandt are beyond you, you can still observe and record and find your own skills increasing as you watch and sketch. Remember that your co-ordination of hand, eye and brain is sure to improve with practice; if there is one secret in the whole process, it's always to carry your sketchbook and a few sharp pencils and be ready to bring them into action as often as possible. When I took a painting party to Morocco, I proposed a morning's drawing on market day in the mountain village where we were staying. Faces fell in my painters' group and some looked very apprehensive at the prospect of working in the middle of such a busy scene. However, tentative beginnings behind a glass of mint tea at the local café soon gave way to much bolder work as the students placed themselves so that they could view the teeming crowds around the stalls. Increasing confidence led to ever stronger and more exhilarating drawing. This session proved to several members of the group that they could stretch their capabilities further than they had imagined – always a worthwhile discovery.

In painting, the actions of the figures are in every case expressive of the purpose in their minds.

Leonardo da Vinci, Notebooks

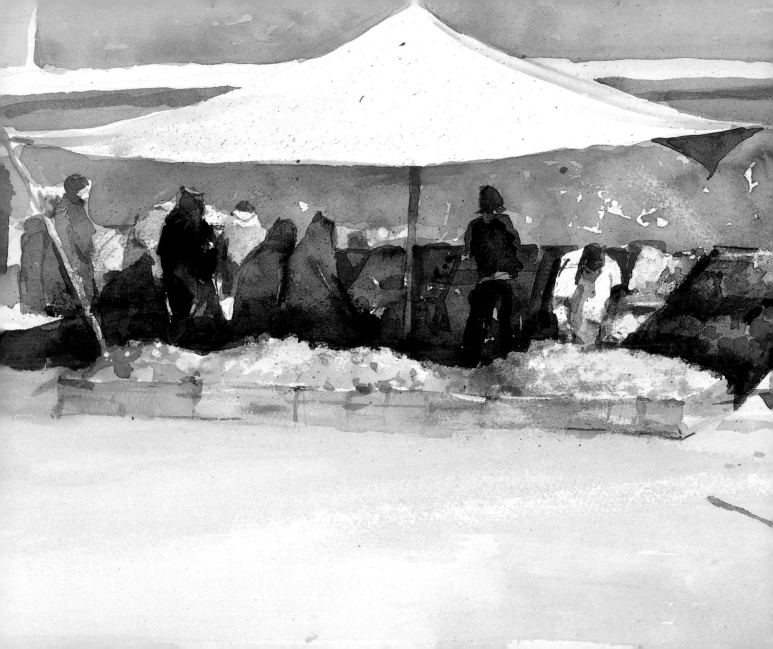

Tafraout Market, *watercolour, 14¹/₂ × 26in (36 × 65cm)*
African sunlight in this south Moroccan market threw the figures beneath the awning into intense silhouette against the pink wall behind. I tried to achieve this intensity with few washes in order to preserve the brilliance and transparency of the darks. The corner of a market stall in the foreground helped to create a space leading to the painting's focus. Strong shadows were helpful here.

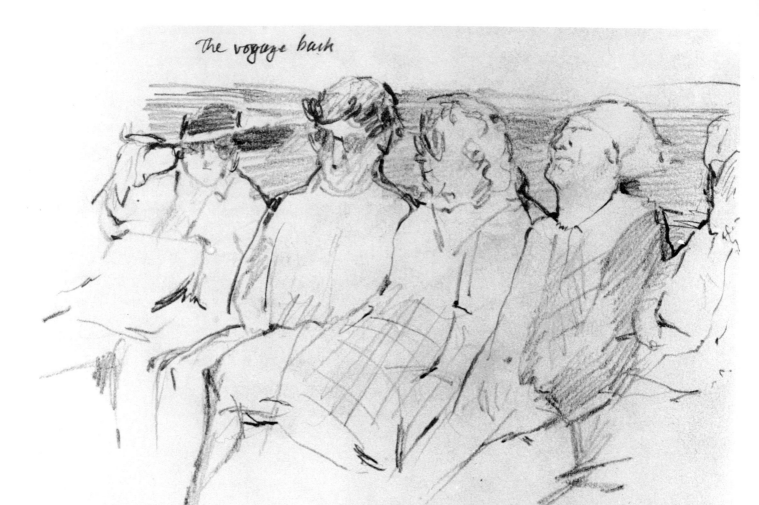

the voyage back

From my sketchbook

144

8
Cities, Towns and Villages

For Italy is very fine. But Paris . . . Ah Paris.

Pierre Auguste Renoir

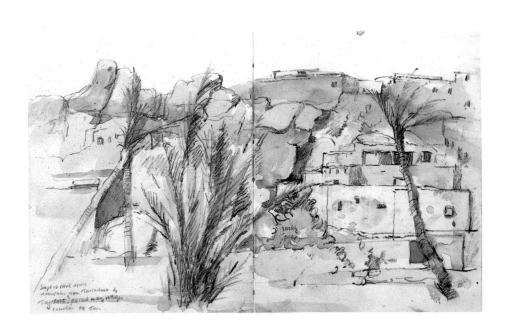

Venice, Paris, Florence, Bruges,
Amsterdam. These are city names
that bring from those who paint a
very special response. Not only are
these established centres of art and
history, they are also places where
painters love to work because of
their pictorial qualities. They are
places where painters can, even in
these busy times, find quiet corners
offering evocative views of houses,
bridges, streets, and canals that
compose sympathetically into
potential pictures. Smaller towns
and villages are traditional starting
points for painters too. But what
are the qualities that make some
groups of buildings attractive to
those who paint, whilst others are
generally spurned?

From my sketchbook

En route in Southern Morocco *(far right),*
watercolour and pastel, 15 × 22in
(38 × 56cm)

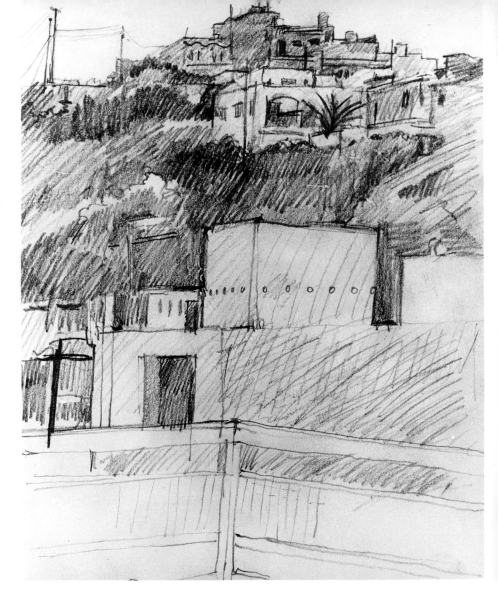

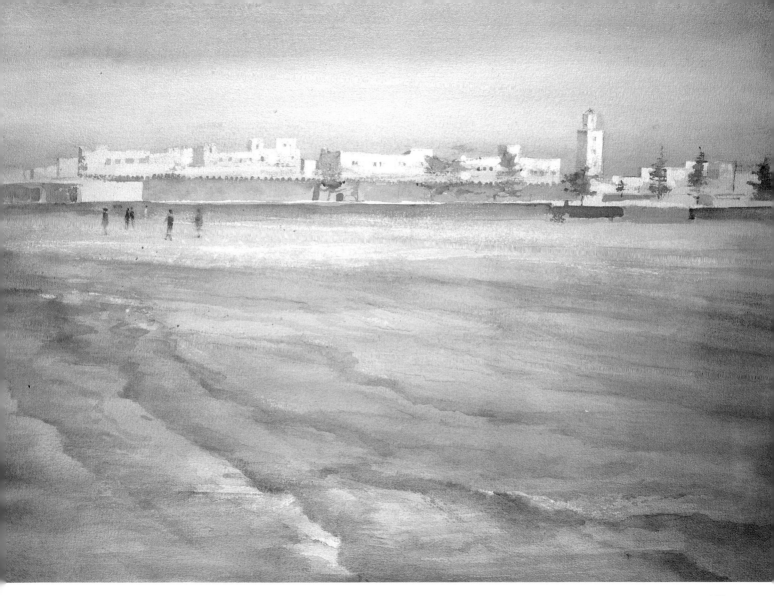

147

From my sketchbook

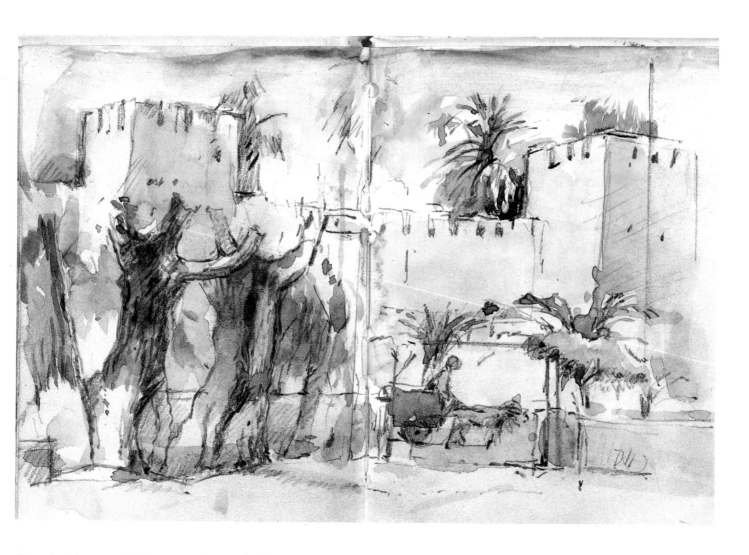

Taroudant, les ramparts. These were the council offices.

From my sketchbook

The Pantheon, Rome, *watercolour,*
14 × 20in (35.5 × 51cm)
This huge building in a relatively small square
meant that I could use the pediment and
columns as a scale for placing the monument
on the left and the foreground figures at the
café.

151

Most painters will look for and enjoy contrasts of scale. A great cathedral against the rooftops of houses offers drama that most people, but painters in particular, can enjoy. A varied silhouette – whether of buildings against the sky or of one building against another – is another element that I find myself looking for when I am searching for possible pictures. I also enjoy abrupt contrasts of dark against light such as those presented by an archway, a bridge or a nearby shadowed building with a light one beyond. Such contrasts may depend in part on strong sunlight, but the sharper forms offered by the built environment will often compensate for a lack of intense lighting. The implications of human presence

Oving, Bucks, England, *oil, 30 × 14in (76 × 36cm)*
Strong emphasis on the silhouette as a method of uniting and simplifying a group of ramshackle buildings beyond which the village church could be seen. The shape of the painting grew from a drawing made vertically across two pages of an A5 sketchbook.

can be another reason for painting in the city or town. You may want to put some figures in your picture, but the very scale of the groupings you are portraying will also suggest that these are places where people live and work. Texture is another important element in city and townscape drawings and paintings; stone, brick, slate, iron, wood – what a challenge these different surfaces and materials present to the painter and what an opportunity to attempt their portrayal in the context of a picture!

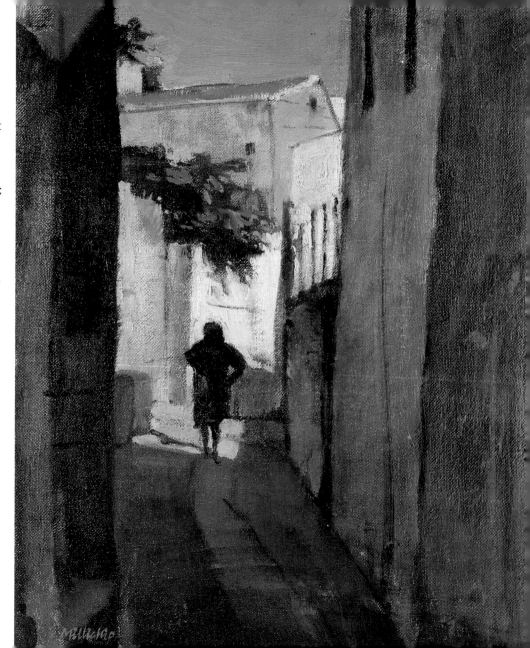

Upper Town, Symi, *oil, 20 × 16in (51 × 41cm)*
A typical glimpse of this steeply-built town. Painted in the studio from notes using a heavily impasted base of white paint, the picture was later glazed to obtain maximum richness from the shadows.

Where water is adjacent to buildings as in the canals of Venice, Amsterdam or Bruges, in the rivers of Paris or Rome or Florence, or in ports or harbours, there is an irresistible combination for most painters. So here is a clue for travelling painters who find themselves in a city and are wondering where to make a start in what may seem at first a complicated environment. If there is water, go for it! The embankments of the Seine, the waterways of Venice, Amsterdam or London provide a strong starting point with buildings, reflections, contrasts of light and shade and scale – perhaps even a bridge to shelter beneath should it rain!

Inquisitiveness is a quality that you should cultivate; explore the back alleys and secluded courtyards of a city or town to penetrate to the life beneath the surface. Simply sitting and drawing in some tucked-away corner and becoming aware of the daily life and comings and goings of the locality should help you to build into your work some sense of the use of which the inhabitants put their town.

We have all seen in exhibitions those sterile picture post-card-like paintings that tell us nothing new or interesting about a place. The painter has simply sat down and painted the most obvious view without considering whether it gave an idea of the essence of the particular town or city. Venice seems to produce a plethora of such work. Acclimatizing yourself to the different atmosphere of a place takes a little time but with persistence the reward should be portrayals that go a step beyond the obviously picturesque.

Bankside, London, watercolour, 11 × 18in (28 × 46cm)
A rapid study in a showery day by the Thames. Wet watercolour over minimal drawing. I worked indoors, nearby, using my sketchbook notes and memory to recreate the scene.

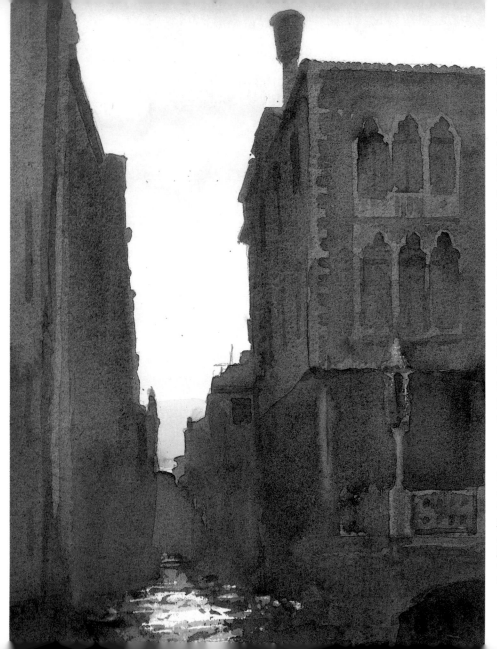

Now you have found a view point that appeals to you. You are sitting, sketchbook open, ready to start work on the preliminary drawing of some aspect of a town, city or village. What a mass of visual information confronts you. Buildings, some near, some further away appear at various angles. Windows, windows, doorways and more windows, signs, lampposts, posts of all kinds in fact; how complex it all is! Somewhere at the back of your mind a voice murmurs something about perspective, eye levels and so on. Try another approach. Look first at the silhouette that the grouped buildings make against the sky. Try drawing carefully that top line silhouette taking in all the chimney pots, television aerials, spires, roof ornaments, changes of contour.

Venice, watercolour, 14 × 10in
(35.5 × 25cm)
Painted using my method of drawing by silhouette. The light sky shape was established first with characteristic Venetian chimneys. Just enough information was added to this first silhouette to define the architecture. Masking fluid was used to create the light on the water.

You may find it more helpful to try to see the sky as a flat white shape round which you draw a line following the contour of the buildings. Either way, this line will provide the mode of establishing the rest of your buildings, since you then use each incident on that line as a reference point for establishing the position of such information as you wish to add below. Position your windows, doors and other details by referring upwards and relating them to whatever point is immediately above them on the building's silhouette. The great advantage of this approach is that you can put in as much or as little building detail as you wish. A good character silhouette will also go a very long way toward establishing the nature of the building you are representing. Think of some famous buildings around the world

Quick study of buildings in Bruges

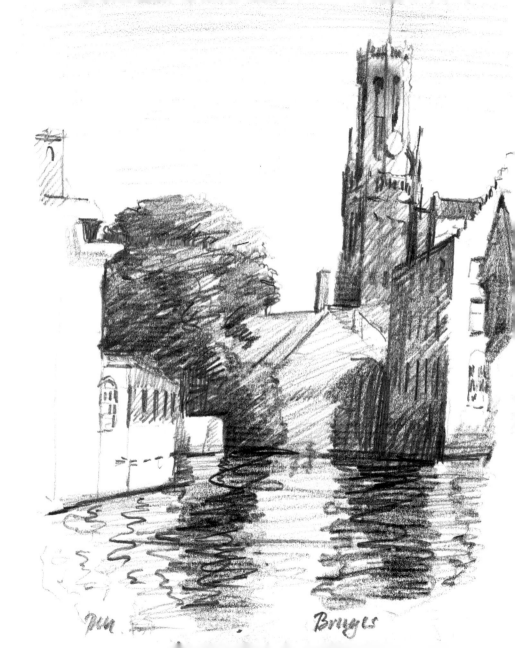

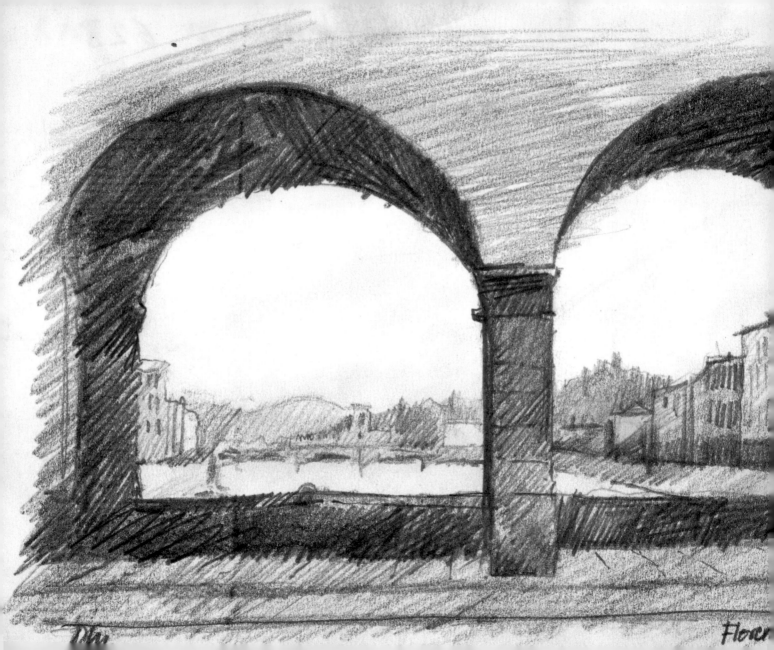

ic Vechio

– Big Ben in London, the Parthenon in Athens, the Arc de Triomphe in Paris, the Empire State Building in New York – in each case your mental picture starts from the overall shape of the building rather than its detail, surely a pointer to you as a painter when you are trying to present the character of a particular building.

If you have no skyline within your vision, use some other all-embracing shape as a starting point such as the top of a row of shop fascias or an important archway. Positioning yourself so that light comes more or less from behind your subject may be helpful in isolating the overall shape. Once the main mass of buildings is established some careful plotting of relevant points in relation to your existing drawn information will help in placing pavement edges, lamposts and other townscape paraphernalia; refer back constantly to that carefully stated contour line that gave you the vital reference points.

I remember a student visiting my studio, desperate to find a way of making a picture of the mixed groupings of buildings of many ages and sizes that form the street in the small town where I live. From my studio the view is down this street and I told him to start by looking for, and drawing the shape of, the sky between the buildings on either side of the street. Once this skyline was established I knew that the initial problem was solved. After about two hours he came rushing into the studio shouting 'I've done it!' like some latter-day Archimedes shouting 'Eureka'. Of course, there remained many more aspects of this painting to tackle but a giant first step had been taken.

If you take a village location as your starting point you will probably find trees and vegetation figuring in your composition. The softer shapes of trees in leaf often tell particularly well against the sharper lines of buildings. Again the use of overall silhouette will be helpful in representing trees. Think how you can tell one type of tree from another by their comparative shapes against the sky. Be aware, though, that much of the pleasure of painting in a village may well be in studying some aspect of it at close quarters. The surfaces of rain-worn brick or timber-cladding have their own delights for us as painters. A broken stone wall or a tottering fence can offer a painting subject that will depend as much on texture as on structure. This is rarely understood by non-painters.

Two alternative composition drawings of village steps

161

Adstock, Bucks, England, oil, 16 × 20in
(41 × 52cm)
*The dilapidated fence on the right with a
clipped hedge beyond made a useful lead into
the focal whitewashed cottage.*

I exhibited a painting of a nearby
ridge-top farm in a local exhibition.
In close up, in the foreground was a
dilapidated post and wire fence,
and I enjoyed painting the abstract
organization of meadow shapes
seen through this barrier,
contrasting them with the surface
of the garden posts. 'Time I did
something about that fence',
murmured the farmer when he
visited the show!

From my sketchbook

Do be aware that your pleasure in painting cities, towns and villages may be just as likely to come from some object near at hand as from a grand panorama of buildings, and it may be that object that can act as a keynote for your entire picture. I enjoyed the textured wall close at hand in a view of Symi in Greece; a strong diagonal shadow across that well helped in creating the abstract organisation of this painting. Be prepared to make the most of the possibilities offered to you by the light on your subject.

View across the harbour, Symi

9
The Sea

The sea a dark greenish blue like a fig

Delacroix

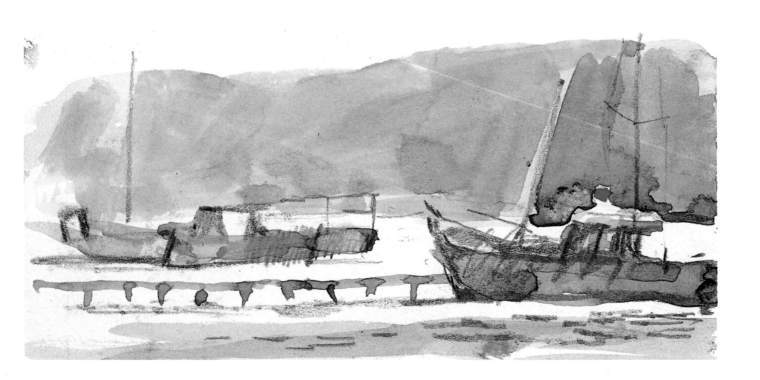

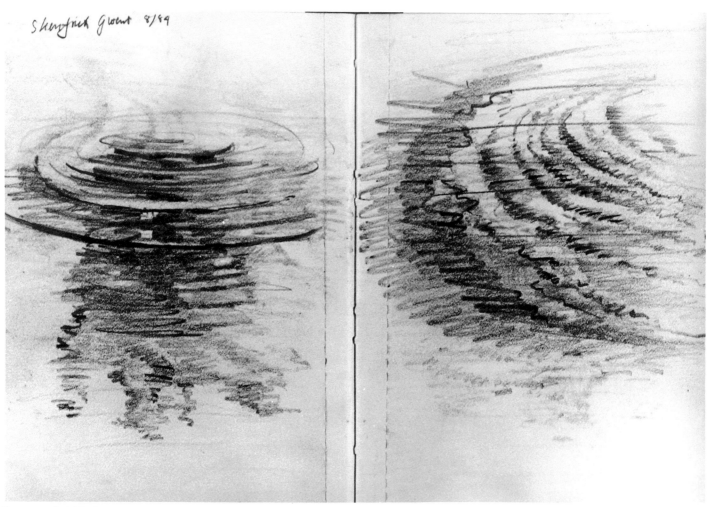

Shenfield Green 8/89

From my sketchbook

For those who have never lived near to it, the sea can possess an almost mythical quality. I recall childhood seaside holidays that began in some great city railway station as preface to a journey, during which excitement rose as the first view of glittering water was glimpsed between hills. Arrival meant the sound of gulls, a wind-blown beach, the 'smell of the ozone' (strongly accented with fish and seaweed), damp sandcastles and dark lodgings. To move house later and to spend some years actually living and painting by the sea offered me a whole new range and scope of subject and lighting. Either way, the seaside experiences held some magic that was further extended by visits to southern seas in France, Spain, Portugal and Greece.

The transparent waters of the Aegean, refracting, reflecting and taking light down into themselves so that the surface reflection patterns were transcribed on the seabed – these have their own excitement, as do the slow, crashing breakers of the Atlantic coasts of Portugal and Morocco. Certainly, those sunlit waters round the isles of Greece and the west Turkish coast can open the painter's eyes to a range of colour and movement capable of transforming for a life-time their vision as artists.

Aegean Shore, Greece, *watercolour,
22 × 29in, (56 × 74cm)*
*The transparency of the waters round the
Greek Islands lends them a special quality of
delicacy merging into richness. I used a
transparent wash of Alizarin for the deep
water first, overlaid with Ultramarine and
Winsor Blue. The greenish foreground was
made with washes of Winsor Yellow and
Yellow Ochre over the blue.*

The problem of capturing that movement and relating it to colour, especially when the water surface has been disturbed by a swimmer or boat, is a fascinating one. In one of my studies I observed varying water patterns, relating them in drawings to swimmers in motion. Looking down from a balcony above the sea was one way of exploiting a vantage point. Standing waist deep in the sea, sketch book in hand, whilst family or friends swam for me, was another. Interpreting all this hard-won information back in my studio was perhaps the most exacting process of all as I tried to capture the interaction of two planes, that of water sliding across that of sea bed. The transparency of watercolour seemed to offer the most accessible method of building my sea images. Wash upon fluid wash could be added to create that vivid spatial flow as swimmers moved through the clear water which changed their warm flesh to

Sigri Swimmer, *watercolour and pastel,*
12 × 21in (31 × 54cm)
Extensive use of masking fluid with successive
washes to make a layered rippled effect, pastel
added for another layer and to increase the
intensity. I wanted the swimming figure to be
barely visible, simply there as a source of the
water pattern.

171

a cool blue-green. Sometimes I found that pastel could add extra fine lines of refracted surface pattern; sometimes I used white body colour applied with brush or knife. Masking fluid played its part too, as did scraping with knife or sandpaper. Certainly, persistence was the most important ingredient as one painting after another thudded into the waste-bin when I had not achieved the transparency, brilliance, movement and balance for which I was searching.

Agios Pavlos, watercolour and pastel, 21 × 30in (54 × 76cm)
Based on sketchbook notes. The swimmer was diving into a shadow cast by our boat on a very hot day in Greece. An initial wash of blue had crimson washed over to make the foreground purple. Transparent yellow created the green at the top and the contrasts were emphasized with pastel.

looking down into harbour water Light from back R.

Studies of Water, *watercolour accented with pastel, 8³/₄ × 8¹/₄in (22 × 21cm)*
Part of a series made while sitting on a stone quayside in Greece. I find this kind of careful observation essential information for my paintings of water.

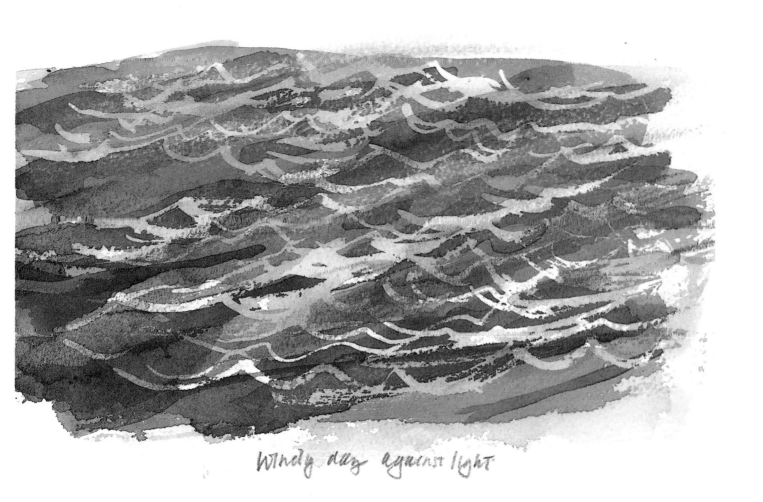

Windy day against light

Most painters will enjoy those wonderful jetties that fishermen and other boat-users build out into shallow ocean waters. Even stone and concrete structures can be transformed by the reflected water's light into iridescent shimmering forms, whilst the shapes and colours of sun-bleached, and sea-scoured wooden jetties can prove a keen inspiration to the painter, especially when they are allied to the colours and varied shapes of the boats tied to them. I certainly found fascination in the wooden jetties of the west coast of Turkey, looking as they did like long, pale, bony fingers pointing ocean-wards. How different from those sophisticated structures accompanied by elegant yachts along the Côte d'Azure in France!

Preliminary sketch of jetty

Jetty at Gumbet, Turkey, watercolour,
$18 \times 11^{1}/_{2}in (47 \times 29cm)$

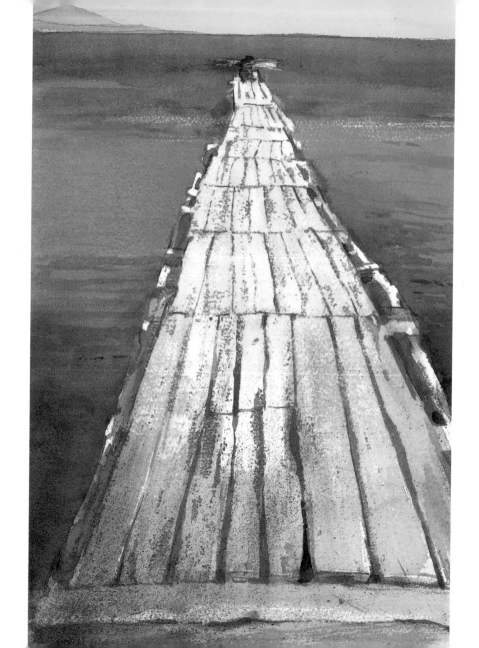

Few travelling painters will fail to be fascinated by boats and most will want to record them. In the Greek islands a boat may well be used daily, much like the family motor car, for sea-access to other parts of an island, for carrying stores, or for taking children to school. Such boats usually have that undemonstrative look of rightness that practical objects in every day use assume, quite different from the smart leisure-yachtsman's craft. I never cease to enjoy the unconcerned skill with which a Greek fisherman manouevres his *caique*, taking in his stride those sudden and violent squalls that can erupt in the Mediterranean.

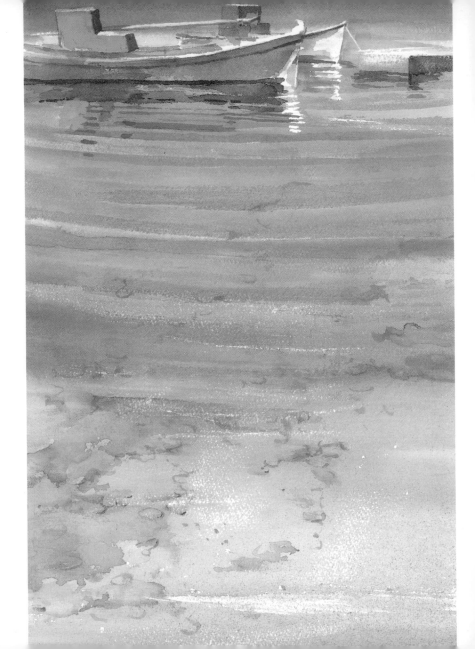

Fishing Fleet, Sigri, Greece, *watercolour, 22 × 13in (56 × 33cm)*
Looking into the light made the sea appear milky, and I used washes of semi-transparent while laid carefully over a graded underpainting to achieve this effect, following on with precise touches of colour for emphasis.

Take your sketchbook to the quayside in a fishing harbour, noting especially the line where the boats meet the water – so often one sees boat pictures where the boats don't sit *in* the water. Look at relative tonal values. If there is a reflection in calm water, is it darker or lighter than the object reflected? In a hot country or in clear light, what part is reflected light playing in this relationship? How are the reflections affected by the water when its surface is disturbed? These are questions that careful observation and a sketchbook can help to answer.

All the apparatus and activity of ports, harbours and boats are, of course, of especial interest to the painter. The forms of bollards in stone, wood or metal, those nets laid out in intricate patterns on quay sides, piles of fish baskets, ropes and boxes, the way in which the arrival of a boat, however common an event this may be, always seems to produce a flurry of activity and groups of interested spectators. The alert painter will try to encapsulate the essence of such a scene by choosing some telling grouping of objects or people rather than attempting an over-ambitious panorama in which the first enthusiasm somehow becomes dissipated in a tangle of masts and rigging!

If you enjoy drawing people a warm day will ensure some interesting groupings on the beach. Seat yourself well back on a flattish beach and, looking seawards, notice how groups of figures are silhouetted against the sea. There is something about the light in a seaside environment which can lend a monumental, even sculptural look to sun bathing and sea disporting folk. In windy places little, gaily-coloured windbreaks may be erected, whilst hot weather brings forth beach umbrellas and tent-like sun shades – all of them making unexpected shapes and patches of colour against sea and shore. Sometimes on the foreshore light-coloured sand or white pebbles will throw light upwards from the ground – an effect worth watching for and recording. Try to include some clues to wind and weather as you work; a flag or towel fluttering, a sailing boat or wind-surfer angled from the

Valtos Beach, Parga, Greece, watercolour, *14 × 21in (36 × 54cm)*
The large spaces of this sandy bathing beach needed figures to give scale. The hard horizon was painted using a ruler.

prevailing breeze, seaside trees or plants bending, the movement of clouds across the sky. Above all, be aware of the sense of space that most beaches produce. Not all pictures need be crammed with incident and empty spaces can be eloquent and compositionally relevant. I certainly do not subscribe to the term 'negative space' in a painting, meaning an area of one's picture containing no 'important' shapes. Since I believe in the importance of the abstract aspect of pictorial organization, every shape in a drawing or painting has to be considered as of value, however large or small. Think of the great formal painting organizers, such as Giotto, Cezanne, Mondrian, Braque, Morandi and ask yourself whether any element in their work could be dispensed with as superfluous.

Valtos Beach Study, Greece, oil, $9^{1}/_{2} \times 16in$ (24 × 41cm)
An on-site study to try out the relative depth of tone and colour on this particular day of light sand, dark sea, hard shadows and the sun shelter floating like a sail against the sea.

182

GÜMÜSLÜK 14/10

185

Of course the sea and shore have much more beside to offer the painter. Viewed from a boat in the Mediterranean or Aegean, the sea deeps are inky blue and intensely dark against the nearest land mass. From land the same sea may appear more benign, but I remember walking out onto a peninsular in western Turkey and seeing a startlingly dark sea against a parched ochre foreground of rock-bordered fields, dotted with yellow flowers; the effect was dramatic, almost threatening, even on a scorchingly hot afternoon. See my watercolour on the previous page.

The western coast of Wales can offer drama of a different kind with tongues of eroded rock pushing out into a slate-grey sea, or natural stone buttresses stressed against high cliffs. On such Atlantic coasts the sea can rarely be seen as a friendly presence despite the long sandy beaches, and even when they are shimmering in a summer heat haze the piled rocks can seem overpowering, with the greys of sun bleached stone turning to blue in the shadows. On a stormy day the Atlantic shoreline can appear grim, with long breakers, polished green on the underside, crashing onto dark grey pebbles. This kind of sea reflects little light and its opacity adds to a sense of crushing power and strength a new challenge for the painters, sitting in the lee of some rock and noting in a sketchbook the superb sculptured forms of waves as they move toward the shore.

Pembrokeshire Beach, Wales, watercolour, 10 × 14in (26 × 36cm)
A rapid note of cliffs and wet sand on a bright morning in Wales with a quality of misty light special to this coast.

Cold sea-mists can appear suddenly, changing the mood of the painter's work and providing another fascinating pictorial problem. Distant headlands suddenly disappear, rocks and figures become intangible silhouettes, the sky is lost. Try working with a brush only, mixing greys from your three primaries and making the most of the chance to show recession in your work by recording the progressively paler tones of more distant objects.

As the moods of the sea change the travelling painter adapts to meet them.

Pembrokeshire Coast, Wales, watercolour, 16 × 26in (41 × 66cm)
Jagged slabs of rock pushing out into the sea with the Atlantic tide pushing in and the wind funnelling up the cliffs. I wanted to bring these movements into this painting. One of the pleasures of painting in northern countries is the additional interest which the dynamics of wind and weather can bring.

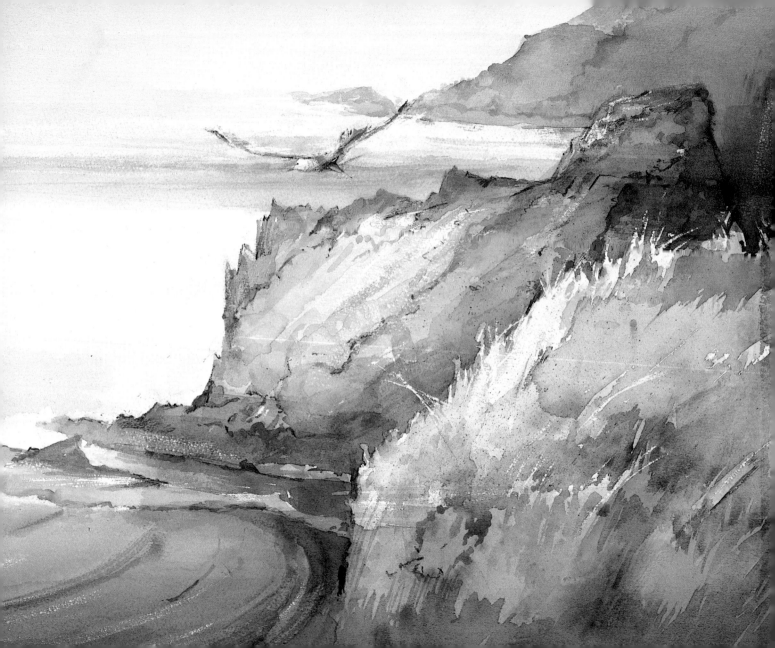

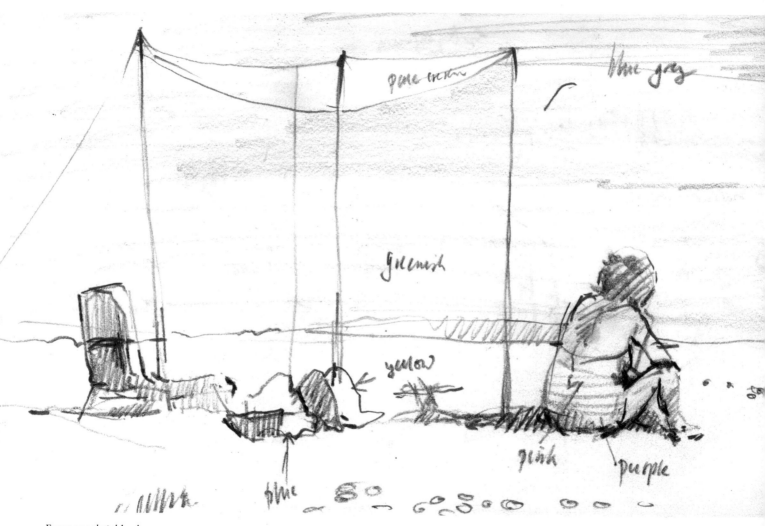

From my sketchbook

190

10
Returning

He had forty-two boxes all carefully packed
With his name clearly printed on each
But since he omitted to mention the fact
They were all left behind on the beach.

Lewis Carroll

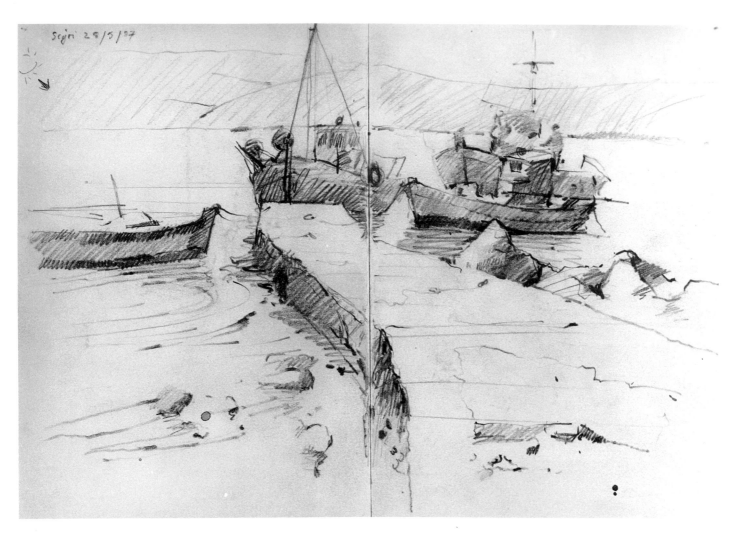

From my sketchbook

192

It may seem fanciful but I always liken the return from a painting journey abroad to the rolling up of a richly patterned carpet that has been spread out and displayed for my enjoyment. A period of a few weeks in a different environment can offer a multi-layered experience of colour, light and subject – pleasures that we fortunate painters have recorded and can continue to enjoy through the drawings and paintings we have done. Even painters, however, are conditioned by sailing schedules and flight times, so although you, as ever, are poised to place that precise brush-stroke that will transform a mediocre picture into a masterpiece, you must look to the practical business of packing, reflecting the while, of course, that your best paintings are the ones that you haven't done yet!

Now is the time to pull out the case from the bottom of the cupboard or from under the bed and consider how to repack it to be sure of the safe return of the work. If you have been painting in oils you will have switched to drawing, or an alternative medium, during the last few days and placed your paintings in a warm or sunny place. This should ensure that your paintings are at least surface-dry. Plastic kitchen film from a wide roll can then be wrapped round the work. You will probably need to touch up the pictures when you arrive home but I suspect you would want to do this anyway. If the paintings are on stretched canvas, you may prefer to remove the tacks, disassemble the stretchers, roll the canvases, painted side outwards, cover with cling film and secure with an elastic band. They can then be re-stretched at home. Alternatively, separator pins can be placed in each corner of a stretched canvas and another of similar size placed over the top and pinned in place at the corners – a procedure especially useful for small paintings. There are various wooden painting separators and carriers on the market that may prove useful, but bear in mind that your stretched canvases or boards plus separators should be the right size to fit comfortably into the bottom of your case.

Some painters like to take a waterproof portfolio with them on painting trips to carry drawings and paintings, but this is yet another piece of baggage to check and carry, so I prefer to place my work flat in the bottom of the case and pack everything else around or on it, much in the order in which I packed it. Large plastic envelopes can be bought from an art supply store and will provide useful protection for watercolours or pastels when these are packed. Plastic bin-liners are useful and cheaper alternatives and will also protect the surface-dry painting if plastic film is not available. Nowadays such plastic items can be purchased abroad in most countries if you forget to bring them.

Friction is probably the greatest enemy of paintings packed in cases, so be sure to pack your work so that it cannot slide around. Remember that you may be searched through customs, so above all pack your paintings so that they cannot be damaged in this way. Secure all tubes and bottles and put them in a sealed plastic bag – do not repack any unused

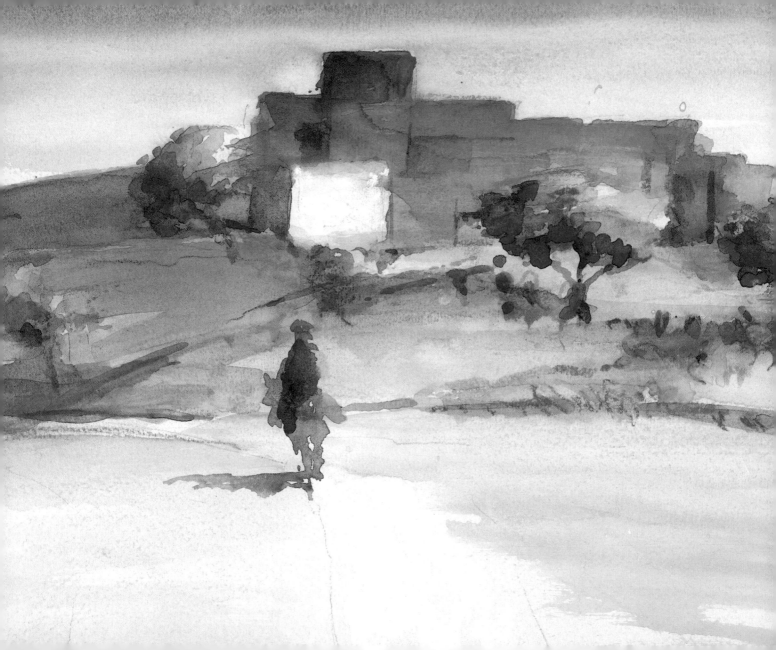

turpentine or white spirit. Sun-tan oil from a leaking container can cause amazing havoc in a case, as can masking fluid; the latter's latex base, as I once discovered, clings tenaciously to all sorts of objects!

As on the voyage out, the sketchbook goes into a shoulder bag. You will undoubtedly find that a week or more of consistent drawing and painting has sharpened your perceptions and your facility to the extent that you feel confident enough to try drawing from a transfer coach or taxi while it is going along the road on the way to a port or airport. Look hard at that gnarled tree or that fascinating doorway, or that farmer on his donkey as you pass them. Register the shape on your mind, remember those silhouettes and try some small rapid drawings from memory while the images remain fresh in your mind.

Morocco, The Road from Tiznit,
watercolour, 14 × 21in (36 × 54cm)

Unfortunately departure delays from ports and airports are all too common these days, so the sketchbook could be a boon again. I always recommend my painting students to keep sketchbooks handy – delays can sometimes see a long row of them in the departure lounge, enthusiastically drawing their fellow passengers.

Once you have arrived home and unpacked your bags put your drawings and paintings somewhere out of sight. Get them out a few days later when you have absorbed the everyday atmosphere of home and feel ready to encounter your work again – always a tough proposition. Do realize that to view your own works with a fresh eye is the most difficult task for any painter. Problems of technique and choice of materials are far less important than the ability to be your own critic and view your own work as if you had never seen it before – that is to say, disinterestedly and objectively. Do not ask anyone else's opinion at this stage; simply pin up or prop up your paintings and, while your travels are still fresh in your mind,

look at each work in turn and ask yourself first, whether it comes close to the idea you were trying to express when you painted it – next, whether an idea is coming through at all! Try very hard to be impersonal as if you had never seen these pictures before and yet bear in mind the mood at which you were aiming. This is not an easy task but one that all painters should set for themselves. The very fact of having travelled away from your usual surroundings should help you to see your work dispassionately. I strongly suspect you will find that the painting you did with such ease and pleasure on that lovely sunny day on the coast will look trite and picture post-card-like when you turn your cool critical gaze upon it – on the other hand that hard fought and over-worked battle-field of a picture of which you despaired may well turn out to be the one that has caught something personal of the mood of the moment.

You are now looking at your work in two lights. First, in the actual light in your room at home, which will help you to see by contrast whether your portrayal of subjects on your travels under a different light has caught that light successfully. Second, in an objective light – with the cool, clear vision of an uninvolved spectator – difficult to achieve but vital for any serious painter.

Keep your paintings on view and look through your sketchbook very carefully, again questioning your own reactions for making each note and drawing. You may well be surprised to find that a quick casual notation contains more potential for a picture than a more elaborate study. On the other hand, the more elaborate study may well provide the full information for a painting done at home which ultimately gets closer to the mood of the travelling moment than any of the work done on site.

Painting is a quirky and capricious business, 'a rum go' as Turner rightly said, and painters who imagine they have found a satisfactory formula for producing pictures will surely discover that the very existence of that formula can vitiate their own creativity. To work in a different environment is a fine antidote to formula painting and preconceived ideas.

As a painter you, more than any other traveller, can return home and unroll again and again that richly woven carpet of personal experience with the thread running through every sight you have seen and drawn. Your awareness of shape, space and colour will enhance every aspect of your journey and your transcription of these experiences may well result in work with which you can re-live, and possibly relay to others, your pleasure in your travels. Whether you decide to share those travels by exhibiting your work, or prefer to keep it as a private memoir, you will surely find that your painter's view of the world will lead to such increasingly acute perception that you will soon be ready to set off and again become a travelling painter.

Bon voyage!

11
Painting places

Everything is beautiful, all that matters is to be able to interpret.

Camille Pissarro

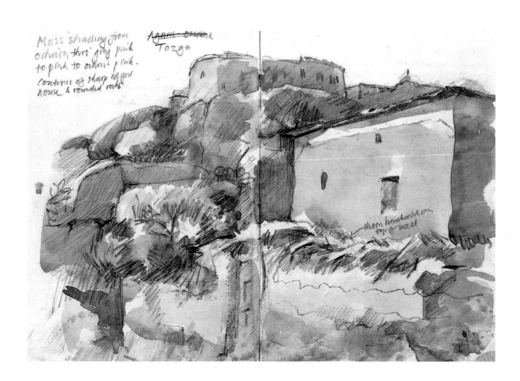

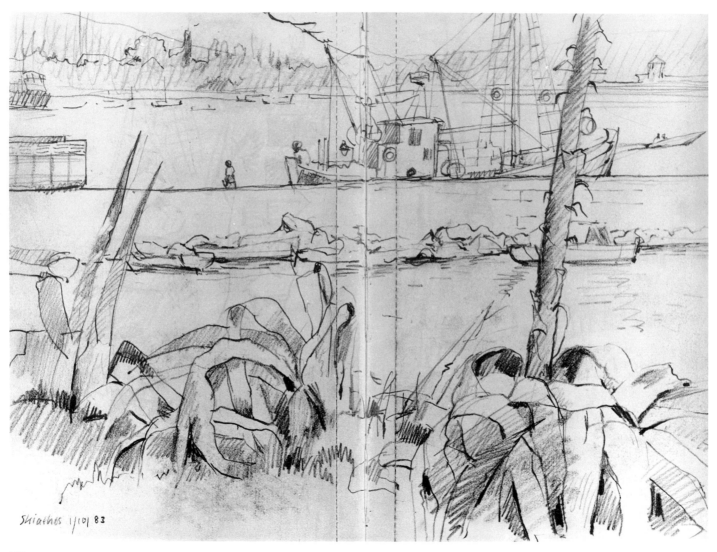

Skiathos 1/10/ 83

Everyone knows the perfect painter's place. The weather is generally warm but not too hot and with it goes strong, but occasionally varied light. There is a wide range of subject matter ranging from harbours to cottages to busy townscape to open landscape with trees, rivers, lakes and mountains along the way. There are cafés, crowds, solitude and silence. We are talking of course about your personally chosen area, country or county or state or district – chosen because its particular qualities offer something special to which you as a painter can respond. We lucky painters do not have to conform to any preconceived ideas or rules about what or where we should paint. We can identify certain painters with particular places; Constable at Dedham, Van Gogh at Arles, Monet at Giverny, Edward Hopper at Cape Cod, Dali at Port Ligat, L.S. Lowry in the British industrial north and many more with Paris, Rome, Venice, New

From my sketchbook

York and London. Just as these famous artists found a working environment that suited them and helped them to make a statement of value in paint, so we can travel, search for and hopefully find the setting with which we shall be in tune.

Rapid travel, especially by air, brings the whole world within the painter's reach – most of us travel far more than we used to and if official predictions are to be believed, will do so even more in the future. It would be invidious to offer here anything other than personal suggestions about likely painting places – suggestions deeply influenced by my own experience of the light, colour and general ambience of the areas I have visited. Many painters I know are rightly loth to recommend their favourite painting places for fear of encouraging heaving crowds and are aware that the artist's paradise of yesterday invariably becomes the tourist maelstrom of today. After all, many non-painters feel that an artist's recommended area must have an extra something that makes it worth a visit. There is also

the cult of the 'beauty spot', a romantic survival from the early nineteenth-century cult of the picturesque. Most beauty spots have now become so overlaid with the detritus of today that they hardly qualify for their special row of stars or other symbols of commendation in the guide books.

Here then, based on personal experience over the last decade or so, are some suggestions for painters who are travelling, or thinking of travelling to another country or another area and following their art.

GREECE

My first visit to Greece started with a taxi ride through darkened streets from the airport to Athens – an electricity-saving scheme made the shadowy streets of the capital seem grim and unwelcoming. Next morning the first sight of the Acropolis, bright against a pale November sky, cleared away many apprehensions, but after a few days I realised that apart from its historic sights, this noisy and polluted city had little to offer me as a painter. For me, the real Greece is its islands, each with distinctive character but sharing a pastoral quality that links one with the past. The modern Greek citizen appears to have lost the visual sense of his forbears, and recent town and village building developments are piecemeal and unlovely, suggestive of projects where both money and enthusiasm have seeped away. However, old-style Greek buildings harmonize with the surroundings and in a few places, notably Lindos, Symi and Skopelos, houses have been conserved and provided with modern amenities.

Despite its tourists, Corfu old town also appealed to me as a painter, as did Mykonos, its charm first revealed to the world through artists. Away from towns and villages, I have painted undisturbed for hours in the exquisite Greek countryside with its mountains, olive groves and rugged shore-lines, all seen in an unparalleled clarity of light.

Sigri Harbour, watercolour, 14 × 23in (36 × 59cm)
My first view of this small Greek fishing village. The bleached quality of rock and tangled twigs on the quayside against the deep slate-blue of the sea creates a desolate atmosphere which I tried to convey through the restricted colour scheme with some scraping, sanding and splatterwork in the foreground to emphasize the dusty feeling of the place.

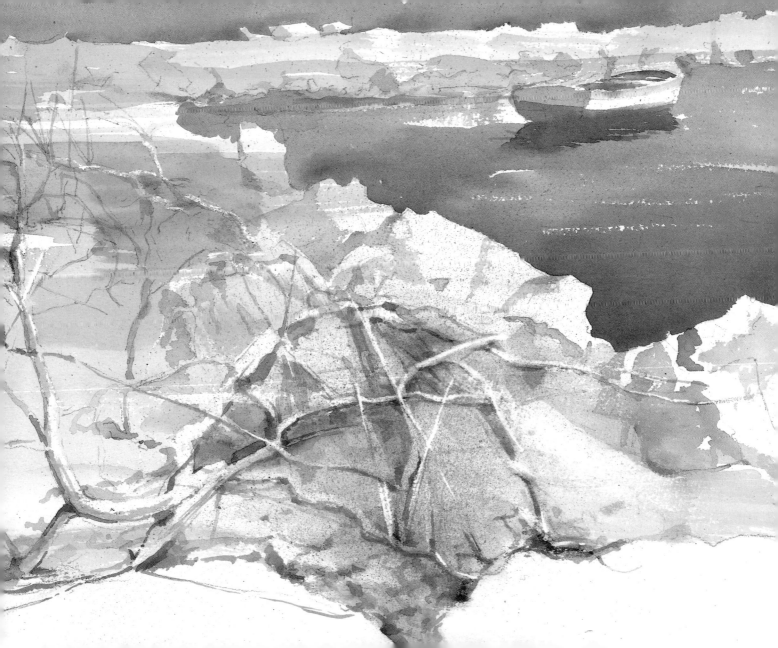

On the islands, Greek village hospitality remains, and I have frequently been brought coffee and cake by folk whose houses I am drawing – all of them, it seems, with relations in America or Australia. The sense of family is strong and I have enjoyed being included in many cheerful domestic meals with wine and good will flowing and energetic music and dancing continuing into the night. Painters from any part of the world can be sure of a friendly welcome in Greece, and its mountains, villages, harbours, boats and people – above all its clear light – will provide an ideal painting environment.

From my sketchbook

202

THE NETHERLANDS

Some years ago I visited the Netherlands to stay with an artist friend who lived in the southern region of Brabant. As he drove me at alarming speed south along straight roads from the airport I recall looking across the low polder countryside and wondering how such a flat country could have produced some of the best landscape painters of the seventeenth century. Later visits have made me more aware of the poetic quality of that landscape, best seen under the cold cloudy light of a winter afternoon, when estuaries glimmer in the dusk and cattle are seen in silhouette against grey-green fields. A town or village can be spotted miles away with its silhouetted rooftops and church protruding from the flat fields – reminders of Van de Velde, the Ruisdaels and above all, Rembrandt.

When I visited Delft, the warm brick of its well-preserved centre threaded with canals brought Vermeer to mind, the artist who so skilfully rendered the texture of Dutch buildings. I always like to intersperse painting in the Netherlands with visits to the many art galleries to remind me of the work of native artists, who made the most of that cool northern light.

Of course, the best place to see the full range of Dutch art is in the great galleries of Amsterdam, but I enjoy drawing in Amsterdam too. I sit by the canals and watch the reflections of the narrow buildings wavering and breaking as boats pass, or record the townspeople as they cross the narrow canal bridges. Other seductive possibilities for pictures in Amsterdam include the busy harbour and docks area, and the colourful floating flower markets. On a chilly day, I enjoy sitting over a drink inside one of the comfortable enclosed pavement cafés and drawing the street scene outside.

The traditional windmills, clogs and aprons will be found further north in fishing towns such as Volendaam and Marken, where houses of painted wood and crowded fishing boats provide tempting subjects for the travelling painter, while Friesland and Griningen districts offer many beautiful towns and villages.

From my sketchbook

MOROCCO

Morocco, a much colonized part of north Africa, offers a cornucopia of experience for the painter. Many of its towns and villages are ancient settlements, which have been overlayed by the French as the main colonizers, but also by the Portuguese, Spanish and others. Arab and Berber influences have combined to produce some extraordinarily mixed environments.

My first visit to Morocco started with a stay in Marrakesh, where the high Atlas mountains tease you into thinking they are just beyond the pink-walled town, when they are actually a long drive away. In the town itself, the main square, the *Jmaa el Fna*, showed the rich spectacle of snake charmers, jugglers, story tellers, musicians and shows of all kinds. I also found the *souks*, or markets of Marrakesh, exciting, especially the dyers quarters where hanks of raw silk are plunged by hand into brilliant dye-vats, then brought out to dry in the sun. On this first visit I booked a seat on one of the daily buses that grind from Marrakesh across the High Atlas to Taroudant. In my sketchbook I covertly recorded the bus passengers sitting cross-legged and smoking to alleviate hunger and nerves as the bus turned hairpin bends within inches of precipitate mountain edges.

Taroudant, south of the High Atlas in the rich Sous Plain, is a good place for a painter to make a stop. Colours of orchards and vineyards lead up to the town with its mud ramparts, and I enjoyed viewing and drawing the town, including its markets and artisan quarters from the seat of a caleche, or horse-drawn carriage.

To the south of the Sous Plain rise the Ante Atlas mountains where colourfully dressed women in the fields sweep their veils across their faces as strangers pass. Central to this region is Tafraout, a market town in a mountain valley of pink and violet rock, defying the painter to catch its colour. Another challenge for me was to record the scene on weekly market days, with exotically dressed tribesmen and Tuaregs gathering for the occasion, and strolling musicians, dancers and singers acting out folk legends.

South again and a drive over to an oasis in the Sahara desert where I stopped to record cubic buildings among cacti, palms and desert rats, with the inevitable television aerial in the middle.

The Atlantic-bordered west coast of Morocco has several attractive towns and ports. My favourite is Essaouira with white buildings and pink town walls, a fishing fleet and boat yards. I found many corners to draw and paint in this beautiful town – its pictorial qualities enhanced by the drifting robed figures of the inhabitants.

Many other regions of Morocco offer fascinating subjects for the painter, and every artist will find a favourite region. Moroccans are always intrigued to see painters working, but I have found the spectators friendly, even if the children can be boisterous. This is a country that offers a new dimension in painting experience.

depths. Ed doing a wonderful job as
driver. Last major evening had a master
to show us — with a great bow wave —
across the flood. 50 dhms well spent!
Our little Peugeot stood up to all this
very well apart from a little water
leaked inside and a jammed door.

From my sketchbook

FRANCE

Paris has traditionally been a mecca for painters, so when I was awarded a travelling art scholarship as a student, it seemed the only place to visit. Paris, and indeed France, have changed a good deal since then but I can still recall the impact those fast-talking, urbane gastronomes, the Parisians, made on me as a teenager. Exciting exhibitions of the work of many of my heroes, Gaugin, Picasso, Matisse amongst them, blended with impressions of a society that despite the deprivations of a recent war, was fiercely guarding its individual quality of cultural life. Although I did some sketchbook work mainly in the Marais, a crumbling area near the Seine now largely redeveloped, I also wanted a glimpse of French rural life, so French friends arranged a stay in a pension in the Cantal in the mountainous region of the Auvergne. Here the farmers still wore smocks and plodded beside wooden hay-carts drawn by bullocks – I have a drawing in my sketchbook to prove it. How foreign it all seemed!

Subsequent visits to France both eroded and confirmed those first impressions. The Normandy coast, camping trips with my own family offered charming Dieppe (Sickert), busy Le Havre (Boudin), Varengeville (Braque), Honfleur (Dufy) and I discovered other evocative towns and villages under that distinctive coastal light. Further tours took in Brittany with its stony fishing villages, its boats with their catches of tuna fish. Next came the Loire valley with its unlived-in chateaux, vast and grey against lush countryside. A later hero figure was Le Corbusier and on a pilgrimage to see his buildings I went east to Belfort to see the Ronchamp chapel. By that time France was prosperous again, and the roads were loud with traffic, but the countryside of the Vosges and Jura mountains was, and still is, superb. On this same visit I made a trip down to Marseille – a huge bustling industrial town with a fragment of its past preserved round the old port. There I could sit at a café table, sketchbook ready to capture a group of fishermen or some moored yachts, or perhaps stroll to a nearby square to record the activities of a game of petanque.

On a later visit to the south, I painted in Cézanne country around Aix-en-Provence, admired the charming inland hill towns of Ramatuelle and Gassin and was duly appalled by the horrors of the coastal areas from Nice and Cannes and further south-west, now largely ruined by ugly development.

Tutoring a painting course in the Dordogne, the region of western-central France that has become so popular with the British, offered a chance to record aspects of rural life in a well-wooded countryside with plenty of attractive market towns and villages.

A large country, France has many jewels for the travelling painter, from the cathedral towns of the north such as Rouen and Chartres to the vineyards of Provence in the south. Painters can feel themselves to be working in a country where art has been recognized and appreciated over many centuries and where that art is within a strong and continuing tradition.

Paris

AMERICA

The Eastern States

The immensity of America could well be a deterrent for a travelling painter, especially if you are unused to the vast distances that can be entailed in travelling from one region to another. I have been fortunate since my travels have been in the company of two American painter friends, concerned that I should see the best of their country adjoining the eastern seaboard, from New Hampshire and Vermont in the north, to North Carolina in the south.

Subject matter and painting possibilities within this region are rich and varied and I will mention what were for me amongst the most outstandingly paintable regions.

Starting such a tour, as I did, in Washington with its multiplicity of wonderful galleries and museums, makes a stimulating prelude to any painter's journey. I then travelled south towards Richmond, Virginia, in a true painter's frame of mind. Richmond has a neo-colonial heart with tree-lined avenues of fine old houses; it is certainly worth a stop for the painter in search of a quintessential eastern city. It also has a splendid art gallery, the Virginia State Gallery, the leading gallery of the state. Driving south from Richmond brought us into countryside that spoke more and more of the American south, the road running through cotton and tobacco fields with many old tobacco-drying barns falling into picturesque decay.

Our base in North Carolina was Morehead City, a place from which painters can explore the interesting Atlantic settlements on the Outer Banks, such as Oriental and Atlantic. In the delightful small towns of New Bern and Beaufort on the sounds, white-boarded houses and white-painted boats, gold-reeded meres, jetties and the general paraphernalia of a waterside town gleam in autumn sun – what more could a painter want?

Painting workshops are common along such an attractive coastline. I spoke with Alex Powers, painter and instructor at several such workshops – his typical schedule is to teach while his students work from the model in the morning, and give individual consultations in the afternoon relating to pictorial design and technique. He specially recommended to me the annual Myrtle Beach workshop in South Carolina, but other workshops are also listed in the magazines *American Artist* and *The Artist's Magazine*.

From my sketchbook

To drive from North Carolina north-west to the Blue Ridge Parkway and the Skyline Drive through the Northern Appalachians was to exchange the greens and whites of waterside communities for the fiery colours of Fall in the mountains. Wonderful blue distances glimpsed on either side between the trees are an invitation to any painter, and beyond the mountains the Shenandoah Valley of Virginia with its emerald fields and neat white farms provides a different colour experience.

On through Pennsylvania with the impressively large timber barns of Dutch settlements including the Amish buildings, distinguished by star-like signs on their sides, a fascinating region with a solid earthy but bleak feeling to it. Frank Lloyd Wright's masterpiece of a house, *Falling Water*, was painted at a stopping-off point here, set in a superb river valley – one of several with highly paintable waterfalls.

New York State followed, wooded and with charming rural areas, then into the rolling farmlands and mountain slopes of Vermont with red-painted wood-timber buildings and covered-in bridges like boxes. No wonder artists have settled here to interpret the landscape. Our road took us on via New Hampshire to the coast at Rockport, a small fishing town in Massachusetts within reach of Boston.

Rockport and adjoining Gloucester are artists' settlements and there are numerous galleries showing work by local painters, including that of the flourishing Rockport Art Society. It was pleasant to sit here on a floating pier in Gloucester marine basin, drawing the clutter of jetties and waterside buildings. I also spent a morning at Eastern Point nearby, painting the light-house, which was brilliant against the blue October sky – a real Edward Hopper motif. This entire coastal area abounds in paintable towns and subjects, and of course the great city of Boston is also a centre for arts in eastern America with its wonderful galleries and collections, and tempting urban subjects for the painter.

Eastern Point Lighthouse

Eastern Point Lig. Massachusetts '8

The tiny state of Rhode Island was the next stop, composed of rocks and dunes, glittering sea and pounding breakers against low-lying land. Shingled houses and wooden-spired churches predominate here. Providence, capital of Rhode Island is the home of the internationally famous Rhode Island School of Design. Travelling from Rhode Island to Connecticut offered an opportunity to see the New Britain Museum of American Art and so gain an overall view in a small museum of a certain obsessional aspect of art in America in the last two hundred years.

Next day was within commuting distance of New York. What can any painter, indeed anyone, say about the visual aspect of New York that has not been said before? Glittering clustered sky-scrapers are a superlative way of reassessing one's sense of scale and confidence in the ability of men to make an extravagant statement, and the world-famous skyline seen from the Hudson and East Rivers offers endless opportunities for interpretation through silhouette.

There are superb art galleries in abundance, such as the Metropolitan Museum, the Museum of Modern Art and the Guggenheim and dealers' galleries in many quarters of the city, including Greenwich Village and Soho. For those who find all this overwhelming but still wish to draw, a fine facility exists in The Art Student's League at 215 West 57th Street where any serious artist can join a figure drawing class with or without instruction.

Next Philadelphia, another great city art collection, plus the famous Barnes Foundation nearby at Merion – the walls of a mansion covered in masterpieces by Cézanne, Seurat, Rousseau, Modigliani, Soutine, Matisse and many others.

South west of Philadelphia is Baltimore, a large bustling city standing on the great Chesapeake Bay. As ever there were contrasts here, for this city, beside the large art institute of Maryland, finds a corner for the Schuler School at 5 East Lafayette Avenue, a small intimate art school and a haven for those who yearn for a stage-by-stage academic approach. The school 'teaches the methods and techniques of the fine arts in the manner of the old masters'.

The Torpedo Factory in Alexandria near Washington, is a large building with over 150 studios run for themselves by artists and craftspeople; it also offers some art instruction.

Bordering Chesapeake Bay are several pretty towns such as Annapolis (the capital of Maryland), a naval and fishing centre, and St Michael's, an exquisitely preserved little town with a much-depicted lighthouse (all very paintable).

Here, then, are a few highlights from my personal experience of eastern America, a taste of a vast country that offers an appropriately wide range of painting possibilities to suit every artist.

BRITAIN

Although I was born in London, I lived for some years in the north of England in Yorkshire. Occasionally as a painter I long for the sight of the Yorkshire Dales, little green valleys crossed by grey stone walls that tuck into the Pennine Chain. Within a very few hours I can be amongst those Dales, a complete landscape contrast to the southern Buckinghamshire countryside of my home. This illustrates the alternatives that can be found within the small area of Britain, an ideal situation for the landscape painter who wishes to deal with the problems of a wide range of subject matter.

I have also lived in Norfolk, flat country in the east of England where fields and marsh land are threaded by rivers and dykes. The horizon is low and a stormy sky can dominate the landscape. No wonder this area and Suffolk to the south have inspired painters for centuries. John Constable, a Suffolk man, made his most loved paintings there. South of Suffolk in Essex are villages so often described as typically English; brick, plaster and thatch predominate, as they do in Kent, which adjoins Essex to the south.

All these counties have a coastline as do Sussex and Hampshire, furthest south. Bordering the sea has inevitably lead to much marine painting in the area but also sadly much ugly urban development, especially near the coast. Local towns such as Eastbourne and Brighton offer town painting subjects with a seaside style of their own. Further west, pastoral Somerset and Dorset are popular with artists, as are the rocky coasts of Devon and Cornwall. Thanks to improved communications, these once remote counties are now easily reached and artists' colonies such as those at St Ives in Cornwall are now world famous. A well-travelled painter friend once told me that the coastal light in Cornwall was still his favourite working light.

All painters who live and work in Britain have a favourite area for painting. Many would push the claims of Cumbria, a traditional painter's and poet's area, beloved of Wordsworth, Richard Wilson and the eighteenth-century watercolourists for a winning combination of cloud-topped mountains and water.

I am especially fond of the countryside across the Welsh border. Pembrokeshire in south Wales presents a rugged yet intimate landscape where I have painted many times. Northwards in the more mountainous Snowdonia area the landscape becomes more dramatic with the cool light changing by the minute and challenging the painter to capture its quality.

Across the border north into Scotland, the strong mountainous landscape, especially along the north west coast, has produced its own school of artists. Turner, that supreme travelling painter, captured the drama and the jagged rocks and turbulent seas of this magnificent landscape. Scotland also has plains and forests, fishing ports and, especially round Glasgow, industrial landscape, to provide plenty of choice.

The great industrial cities of the north and Midlands also have their interpreters in paint as have the much-painted cathedral cities of Durham, York, Norwich and Canterbury. I have often sat and made drawings within quiet cathedral precincts, which have an enclosed atmosphere of unique tranquility.

From my sketchbook

Variety of subject, colour and mood can be said then to be the qualities the painter will encounter in Britain, an opportunity to meet an ever changing pictorial challenge.

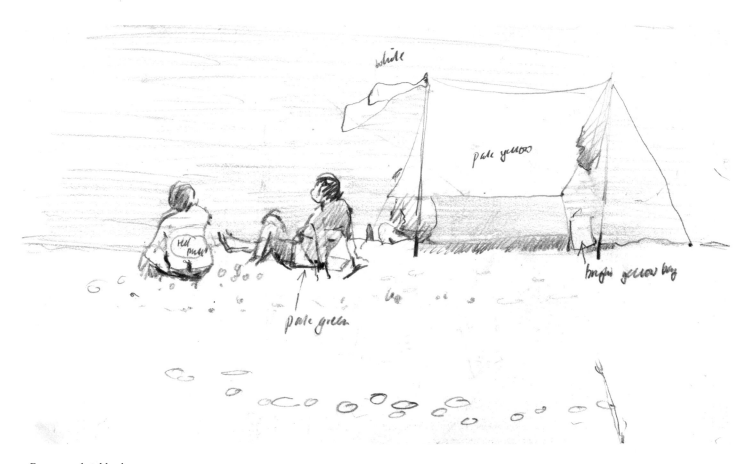

From my sketchbook

218

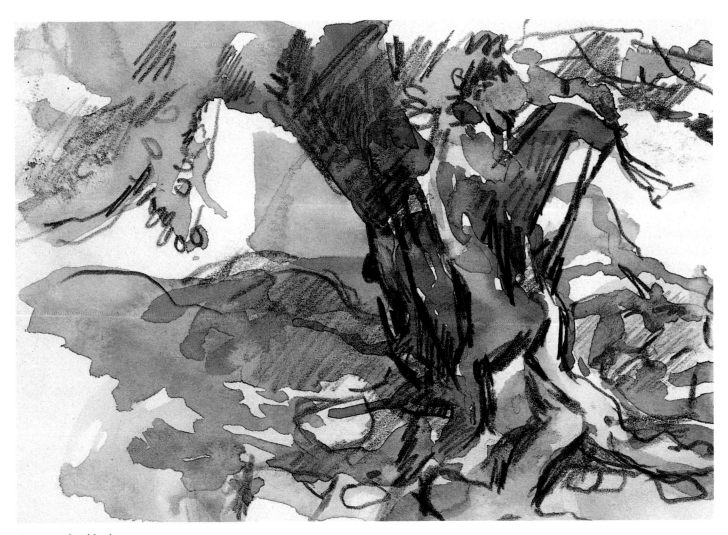

From my sketchbook

ITALY

A period of study in Italy used to be a vital part of an artist's education. This is no longer the case, but artists are still attracted there by the unequalled opportunity to see the rich heritage of art and to paint in Italy's beautiful cities and countryside. Like many others, I can vividly remember my first visit to Florence, standing by the River Arno and drawing the Ponte Vecchio, finding subjects in the Boboli Gardens, then braving the congested narrow streets to study yet another exquisite fresco tucked away in some back-street church. For a quieter time, I took the bus up to Fiesole nearby, where the city view is spread out below in the sunshine, asking to be painted. Excursions through the surrounding Tuscan countryside were also a pleasure, with its reminiscences of the trees and hills behind the shoulders of fifteenth-century Madonnas in the Uffizi gallery.

One such excursion was to Siena, that beautifully preserved mediaeval city with its shell-shaped piazza and grandiose cathedral, both of them the inspiration of countless painters. When you have tired of city delights, you can then return to the Tuscan landscape to paint cypresses, pines and rounded hills interspersed with pink pantiled roofs and churches.

Further north is Venice, the world's most painted city, with its palace-lined canals complete with wiggly reflections appearing in virtually every exhibition around the world. None of this takes away from its beauty and appeal however, and I can remember the thrill as I stood one early spring morning waiting for the vaporetto at St Marco looking across at St Georgio Maggiore veiled in a light mist, and realizing that the view was identical to my favourite Turner watercolour. The light reflecting from the canals of Venice onto its stone and brick can give the city an ethereal quality. Many have tried to capture this light but few have succeeded.

Although Rome is a big, noisy, traffic-crowded city, there are still plenty of places there for painters to work. It is certainly fascinating for an artist to be in a city that offers over 2000 years of artistic history and in so many different forms. I sat and drew in the corner of the Roman Forum enjoying the texture and shape of broken columns and ruined walls. These close-ups can often say as much about a place as the grand view. There are many secluded courtyards and squares to be discovered in Rome, but to find quieter painting sites nearby, I took a bus a stop or two down the Appian Way, an ancient route to the port of Ostia. Plenty of subjects present themselves here and if a visit can be made either early or late in the year, avoiding summer heat and crowds, the painting will be even more enjoyable.

From my sketchbook

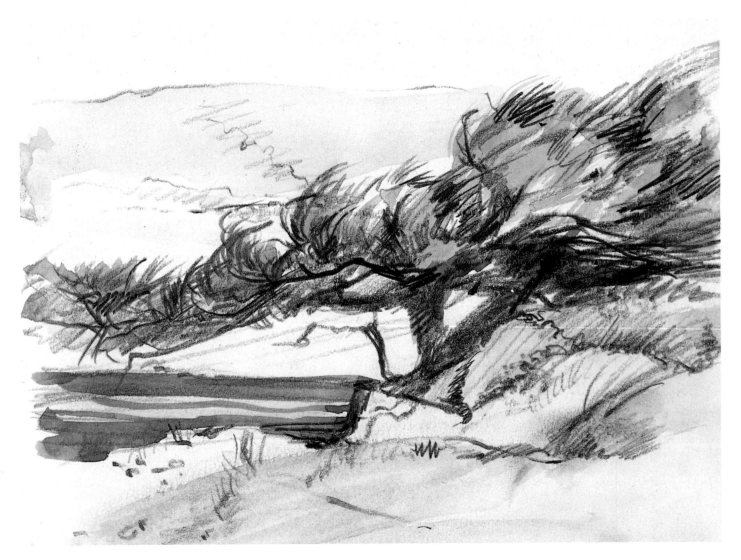

PORTUGAL

As in many other countries, the main tourist developments in Portugal have been along the coast. The Algarve, or south coast of Portugal, has developed very rapidly over the last twenty years, and one-time fishing villages are often hemmed in by holiday villas. When I painted in south Portugal I generally preferred to go inland to towns and villages in the mountains, such as Monchique and Silves. Here I could find and draw old-style houses with pantiled roofs, tall decorated chimneys and a certain sense of mountain peace. However, at fishing ports such as Portimão there are plenty of boats unloading the day's catch of sardines amidst the typical hustle and clatter of the quayside.

Portugal's capital, Lisbon, is a port with a beautiful waterfront full of life and activity, presenting lots of possibilities for the painter. Behind the town is the Gulbenkian Museum, which has one of the world's finest art collections.

Within easy reach of the capital along the coast is the Estramadura area with towns such as Sintra with great houses in a mountain setting, and seaside places such as Cascais with old-style boats on the beach. North of Lisbon by about 150 miles is the Oporto region, with lovely mountainous countryside inland.

Portugal can be a rewarding country for painters where, away from the coast, delightful villages and a rural way of life are waiting to be painted.

Index

acrylic paints 34
advertisements 27
America 210–14
Amsterdam 23, 146, 154, 203
Athens 159

baggage weight 41
Barcelona 113
boards, painting 31
Boudin 208
brochures, travel agents' 18
Bruges 146, 154
brushes 32

camera 35
canvas, stretching 31
case, packing 27–38
clothing 35–6
colour, complementary 128
colours, basic 32
Constable 60, 199, 215
crayons 74
cushion, inflatable 34

Dali 199
Delaunay 17
Dufy 208

easels 34
equipment, first day 51
excursions
 equipment 86
 selecting subject 86
 transport 81–6
eye, tuning the 51–2

flashlight 36, 74
fly-drive 15
Florence 146, 154, 220
France 167, 176, 208

Greek Islands 178
Greece 35, 43, 74, 97, 99, 100, 102,
 111, 140, 167, 200
greys, mixing from primaries 188
Giotto 182
gouache 74

headgear, lightweight 36, 86
Hopper 199, 212

immunization 38
Italy 220

junk, as subject 121

knife
 painting/craft 32
 scraping with 173

light
 position of 64, 164
 on water 89
London 159
Lowry 199

masking fluid 173, 195
Matisse 208, 214
Michelangelo 60
Modigliani 214
Mondrian 182
Monet 17, 199
Morocco 86, 141, 167, 205
mosquito repellent 38
multi-centre 17

Netherlands 74
New York 159, 214
New York State 212
night painting 74
Nolde 70

oil paints 27, 31, 32, 67, 70

palettes 32
paper
 drawing 28
 stretching 30
 watercolour 28
Paris 146, 154, 159
pastels 27, 34, 173
people 125, 144
Picasso 60, 121, 208
pictures, from drawings 64
pochade boxes 35
portraits 140
Portugal 167, 222

Rembrandt 203
return
 packing 193
 unpacking 195–6
Rome 154, 220

Ruisdael 203
rucksack, lightweight 27

sandpaper, uses when painting 173
scale, figures to convey 128
shoulder bag 35
silhouettes, observing 133
site, selecting 64
sketchbooks, use of 13, 35, 41, 54, 95,
 179
Spain 167
Sri Lanka 42, 113
still-life 70
stools, folding 34
strip, tonal 59
suitcase 27

table, for working 46
texture 164

Turkey 176, 186
Turner 70, 196, 220
turpentine 32
tutors 13

Van de Velde 203
Van Gogh 60, 64, 199
Venice 22, 27, 146, 154, 220
viewpoint 170, 180

Wales 122, 187
Washington 210
water
 containers 33
 in cities 154
watercolours 27, 32, 34
Watteau 81
workshops 13–5